To Robert with best
wishes!

Paul T. Brown

10-28-98

Paul Brown's

WILD VISIONS

True Exposures Publishing, Inc.

Brandon, Mississippi

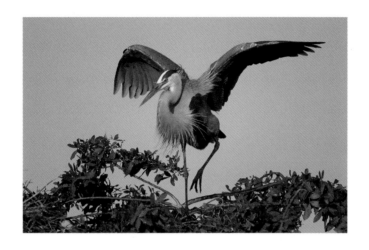

Published and distributed by:
True Exposures Publishing, Inc.
PO Box 5066
Brandon, MS 39042
601-829-1222
800-323-3398

Library of Congress Catalog Number: 98-090368

ISBN: 0-9642595-1-6

Color separations: DDL Kaminer
Madison, Mississippi

Printed in Korea

Photography: Paul T. Brown
Book Design: Dennis J. Heckler

INTRODUCTION

\mathcal{M}y quest as a photographer is to capture visions on film that reflect my feelings for my subjects. My visions embody special moments where all the ingredients of photography-light, animals and their behavior, habitat and composition- come together to form a vision. I call such a moment a *Wild Vision.*

An athlete sometimes refers to being in "the zone" or experiencing a "white moment," that fraction of time when everything comes together. Writers, actors, musicians and many other professionals, including photographers, experience this state of mind. Such a moment occurred for me, for example, when I was in "the zone" while photographing the two bull elk on pages 94 and 95. I was so enthralled in photographing the two giant bulls that I became part of the action. So fine-tuned and focused was I that nothing else entered my mind. There were no conscious thoughts of *f*-stops, shutter speeds, composition or rules. My mind was clearly focused on the moment. My intuition was in full command.

Once the bull fight ended it took several minutes to exit "the zone" or return to earth. I felt exhausted. I could not remember how many frames of film I had shot. Was it 12 frames or 12 rolls of film? I only could recall the thrill of being very much a part of the battle.

These moments, or visions, make wildlife photography my passion.

Rarely are my photographs preconceived. Instead, they are products of my intuitive responses, triggered by my experiences, feelings, knowledge and values.

Though I may set out to photograph a particular animal in a certain environment, I approach the subject with an open mind so I can remain alert to any opportunities that offer me these unique visions.

Wildlife photography has taken me to many wonderful places. I have worked close to a wide variety of animals. The images within this book portray my favorite species. So-called "big-game" animals perhaps capture my attention more than any others. No creature is unimportant, every life form is ultimately linked to the other. However, those larger mammals seem always to lure me to their lair.

I hold no animal in higher regard than the white-tailed deer. I marvel at its keen senses. No other animal can vanish with such speed and grace as the whitetail. However, as much as I revere the whitetail, every animal in this book has my respect and adoration; each image evokes its own special memory.

The events in nature I have been so privileged to witness are infinite: snow geese by the tens of thousands, honking wildly as they drift downward into a corn field; thousands of mallards rising in unison from a flooded field; the harsh game of survival played out as a coyote scrounges in minus 10 degree howling winds for the final morsels on a frozen bison carcass; a great egret's 20-minute struggle with a water snake before finally swallowing it; animated wild babies playing, learning and fighting with each other; and proud white-tailed bucks slipping along ridges against a golden autumn backdrop.

Photographing species listed as *Endangered* or *Threatened* is truly gratifying. The American alligator, and crocodile; grizzly bear, scrub jay, wood stork, spotted owl and several others have contributed to photographs that document their existence in the wild.

Wildlife photography has enriched my life in so many ways. Through this collection of photographs, I hope to share with you some of my *Wild Visions*.

Paul

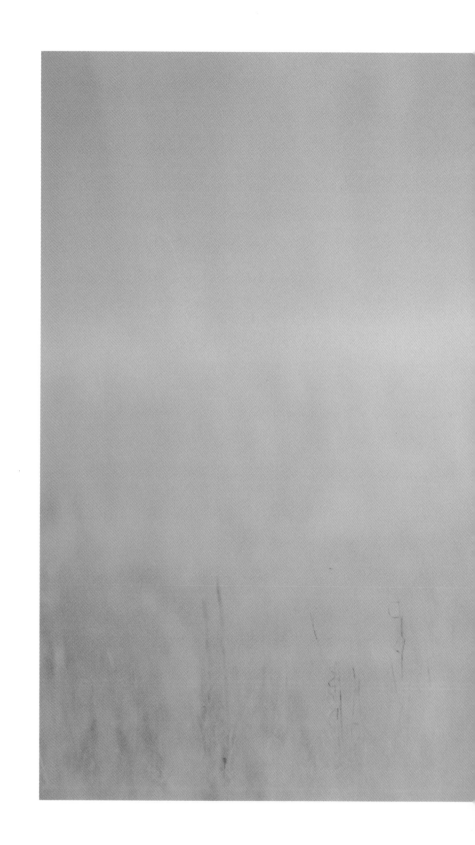

"To be beautiful and to be calm is the ideal of nature."

RICHARD JEFFERIES

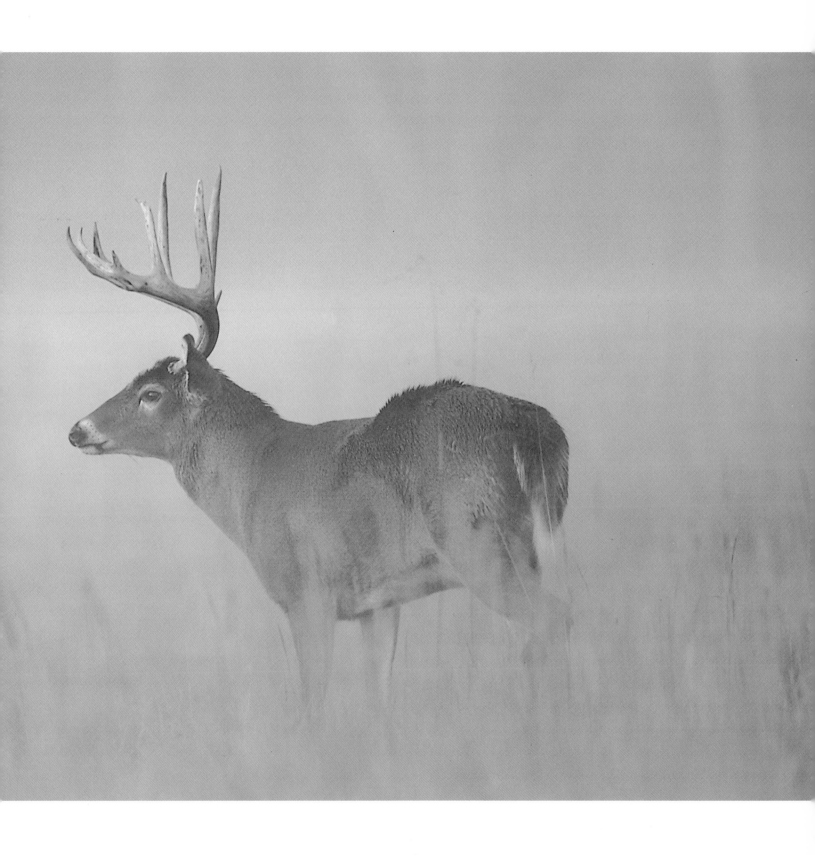

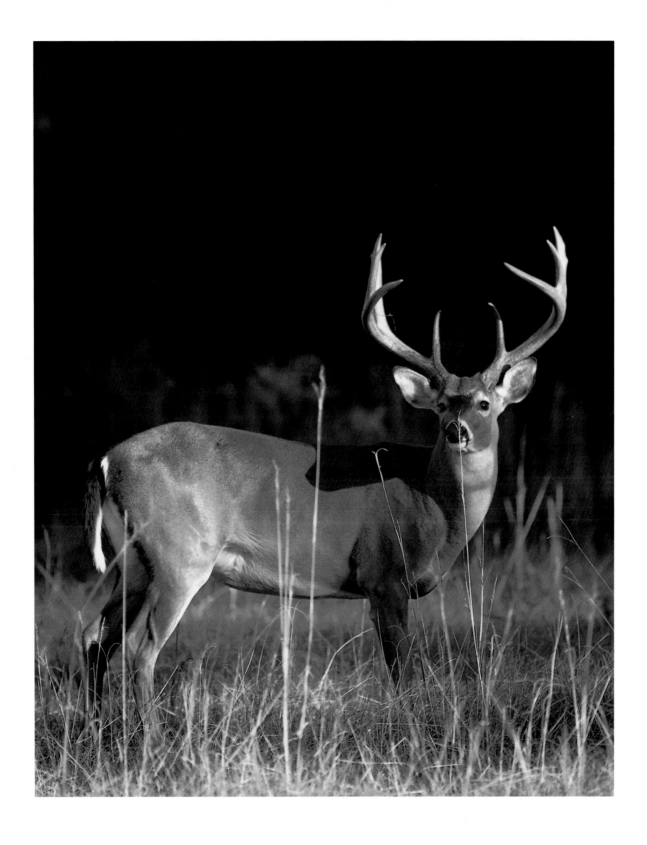

*"In the woods
we return to reason
and faith."*

RALPH WALDO EMERSON

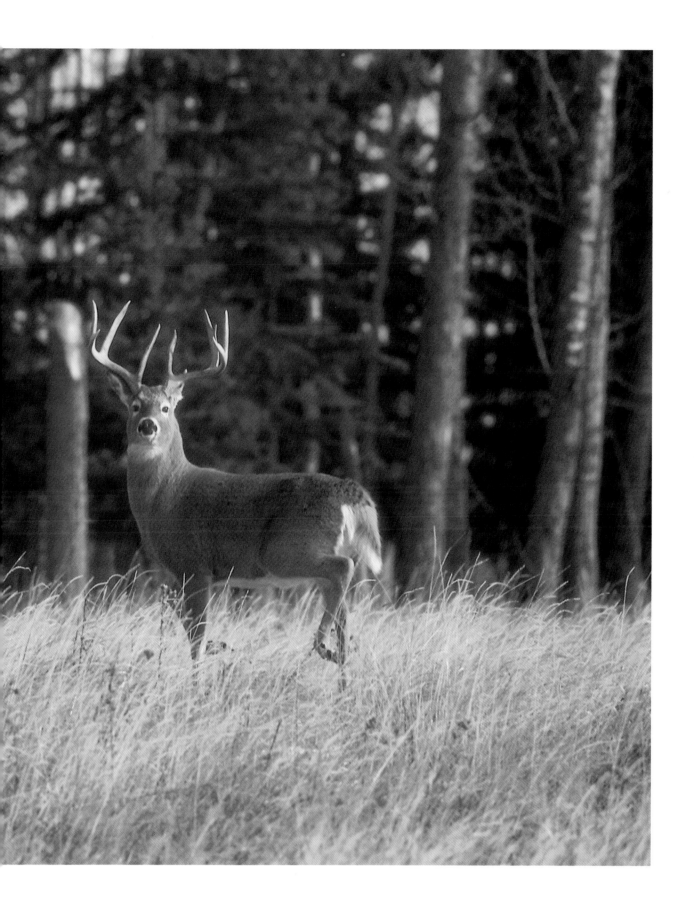

12

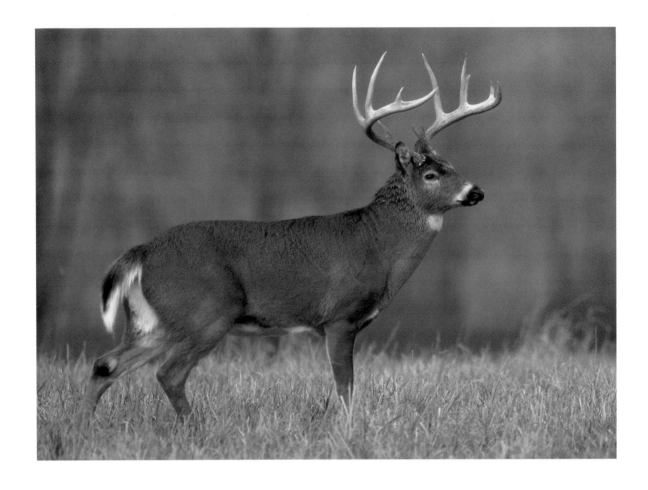

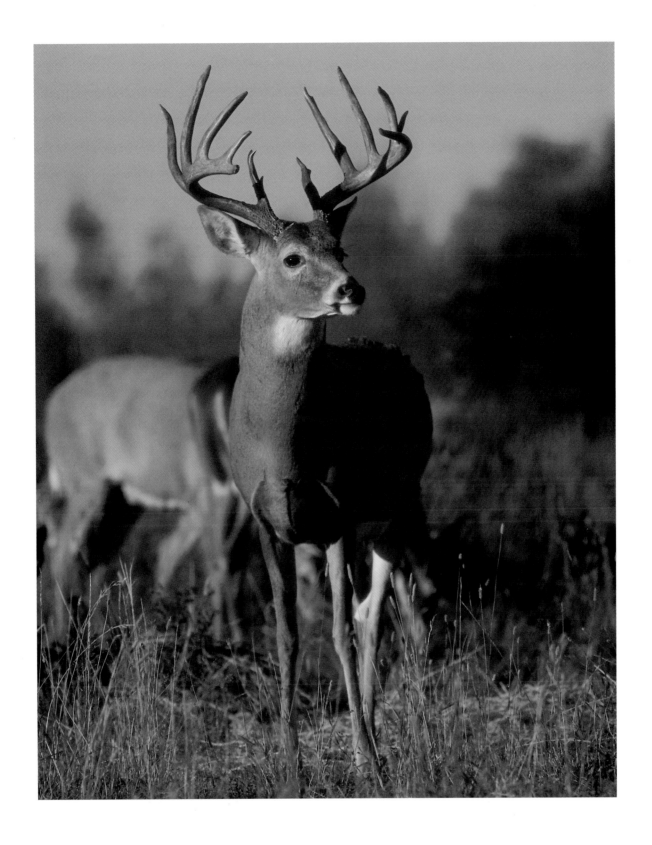

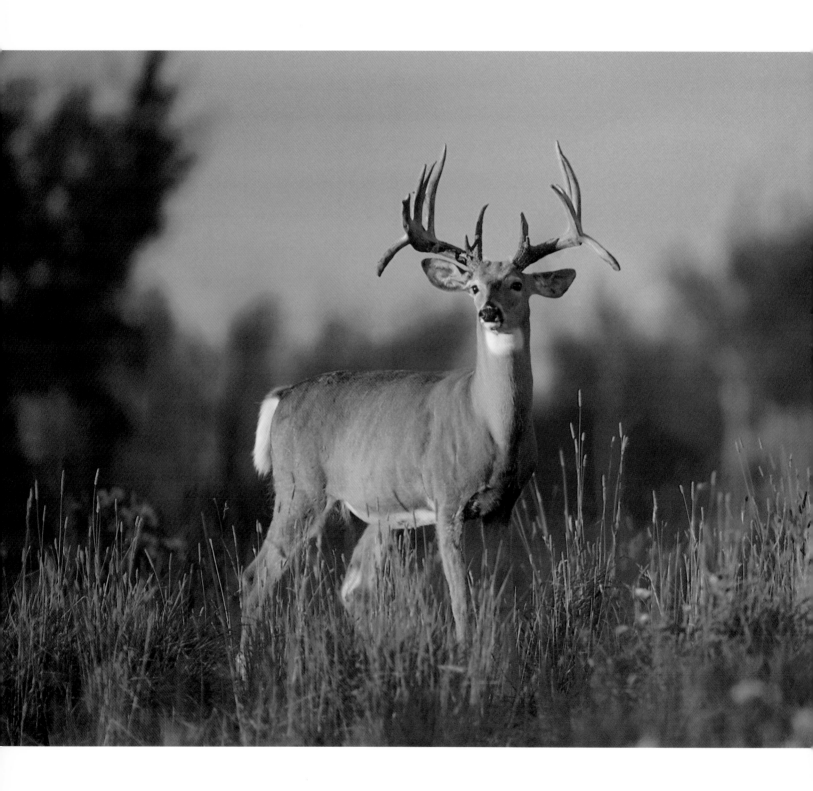

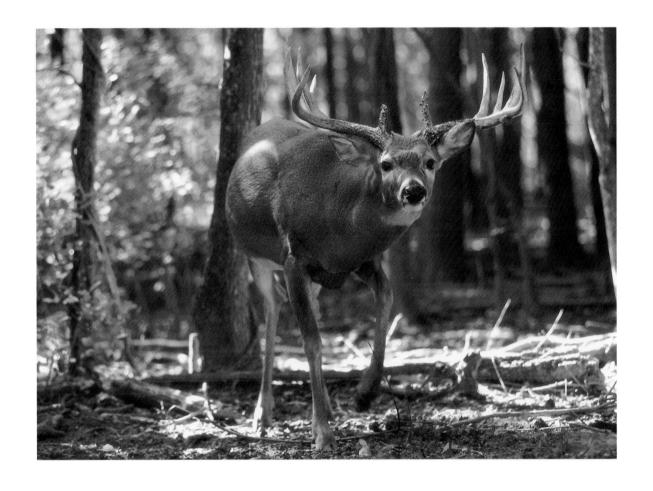

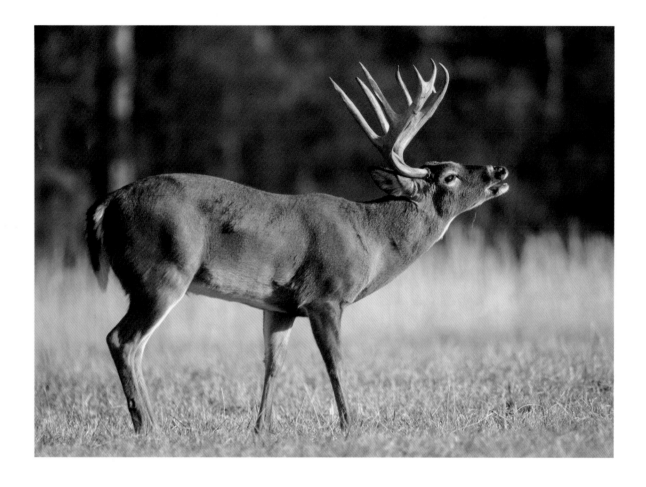

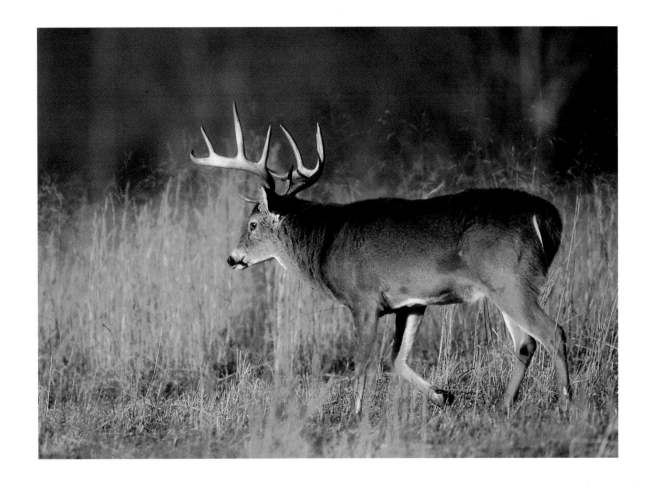

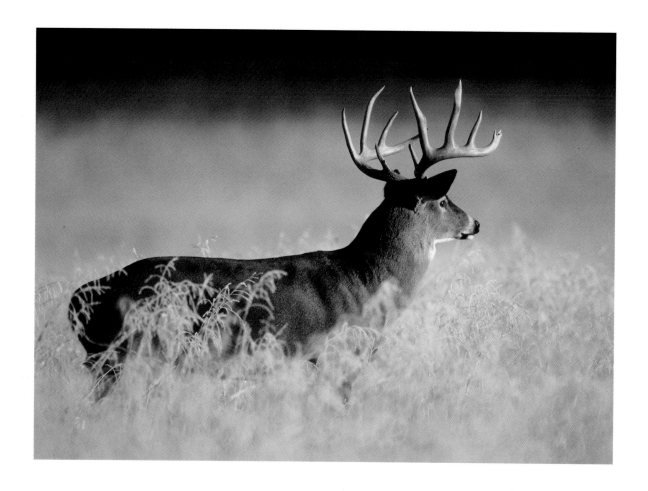

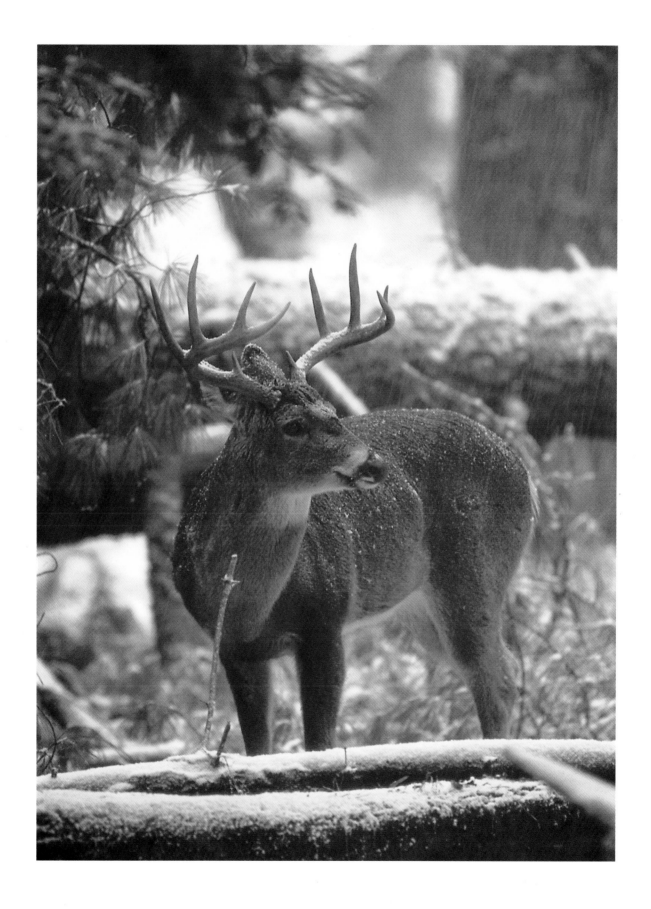

"*I never saw a wild
thing sorry for itself.*"

D. H. LAWRENCE

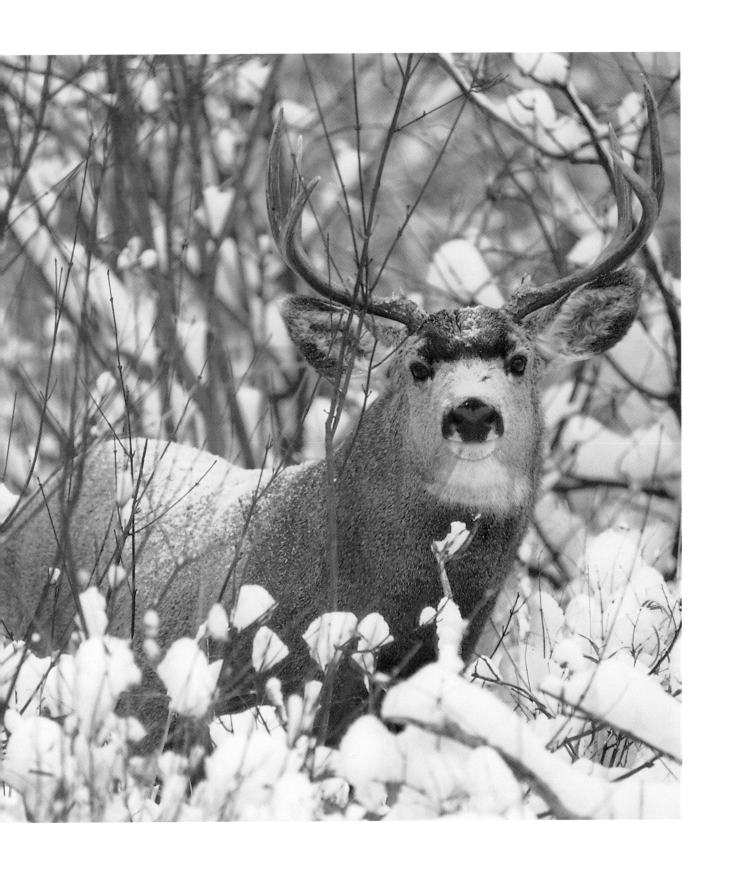

24

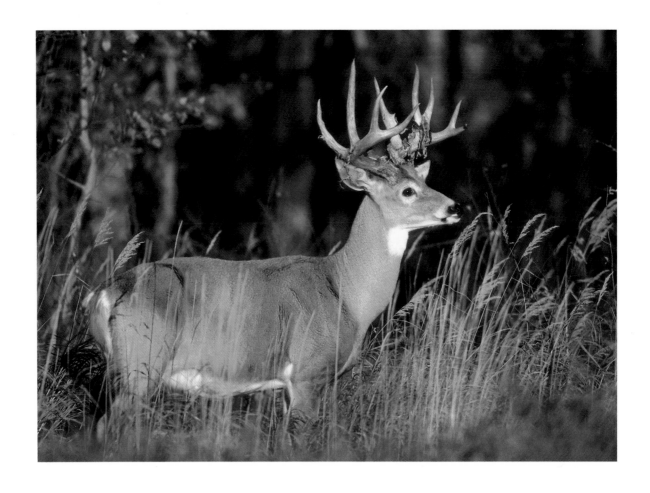

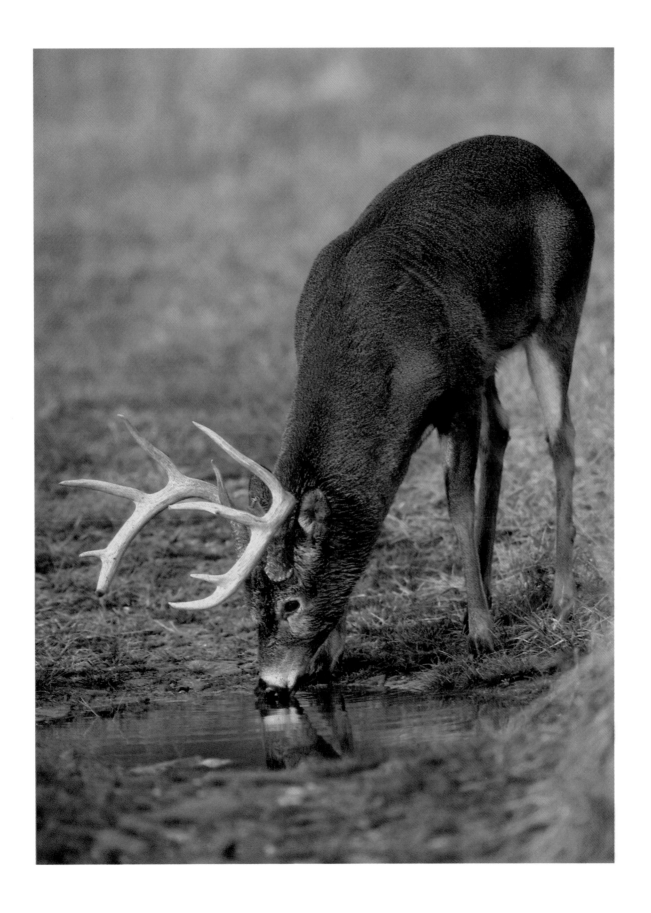

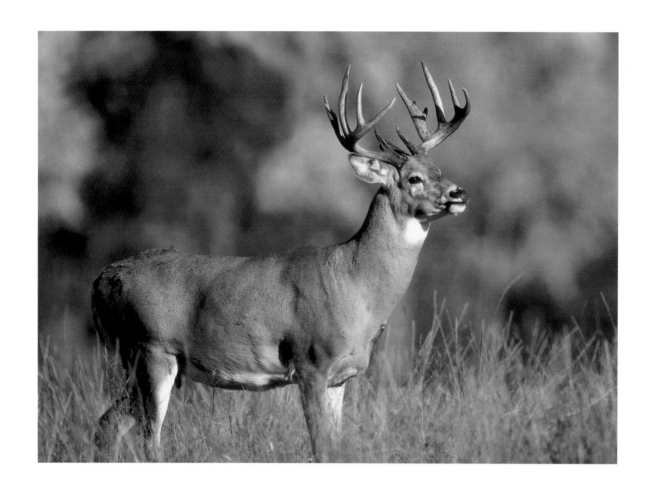

27

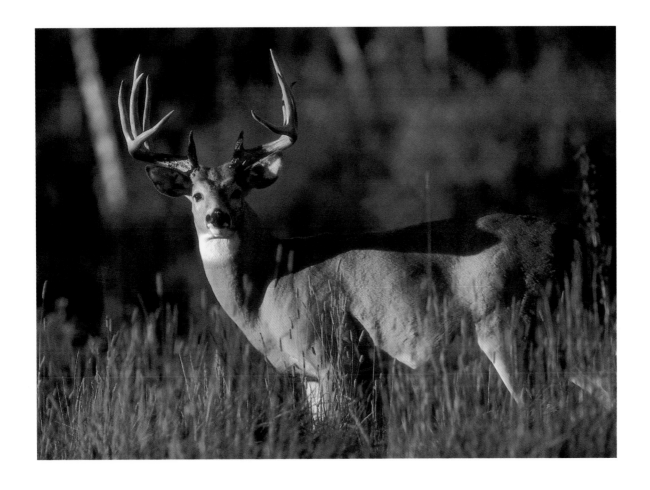

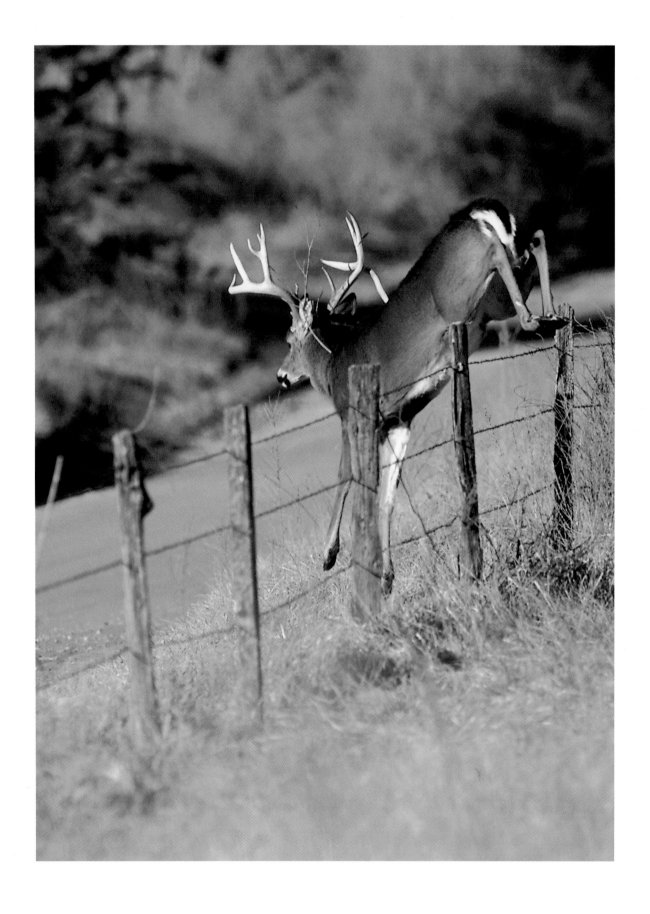

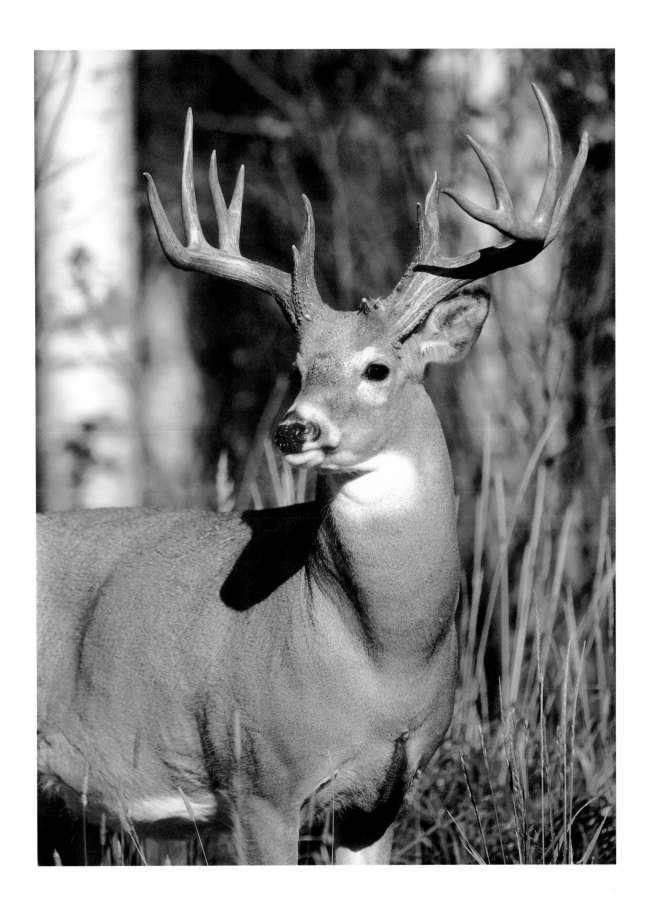

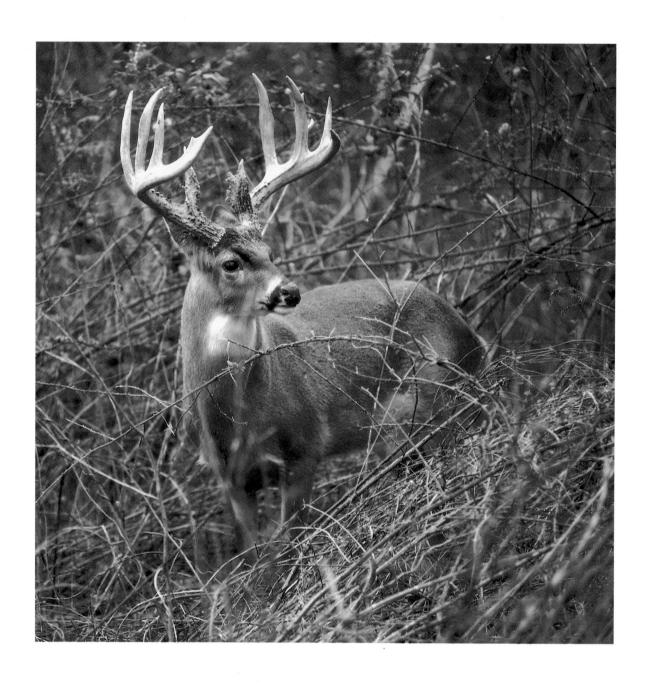

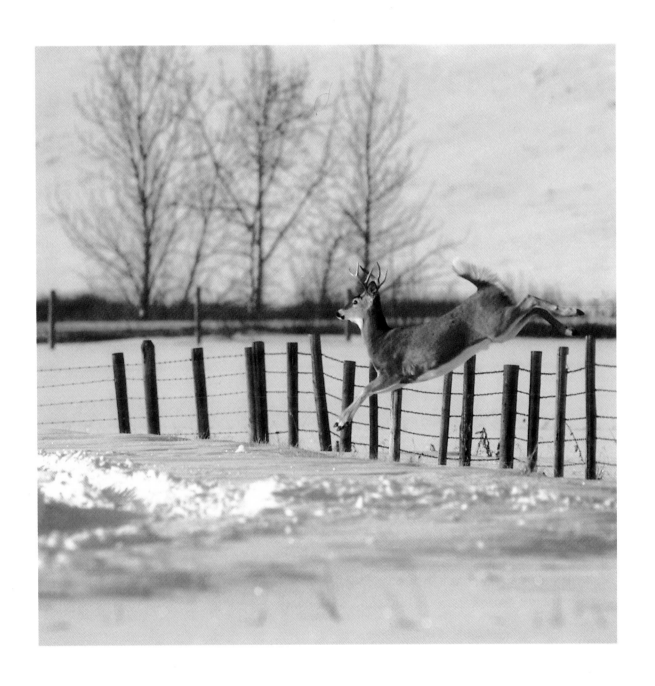

"No synonym for God is so perfect as beauty."

JOHN MUIR

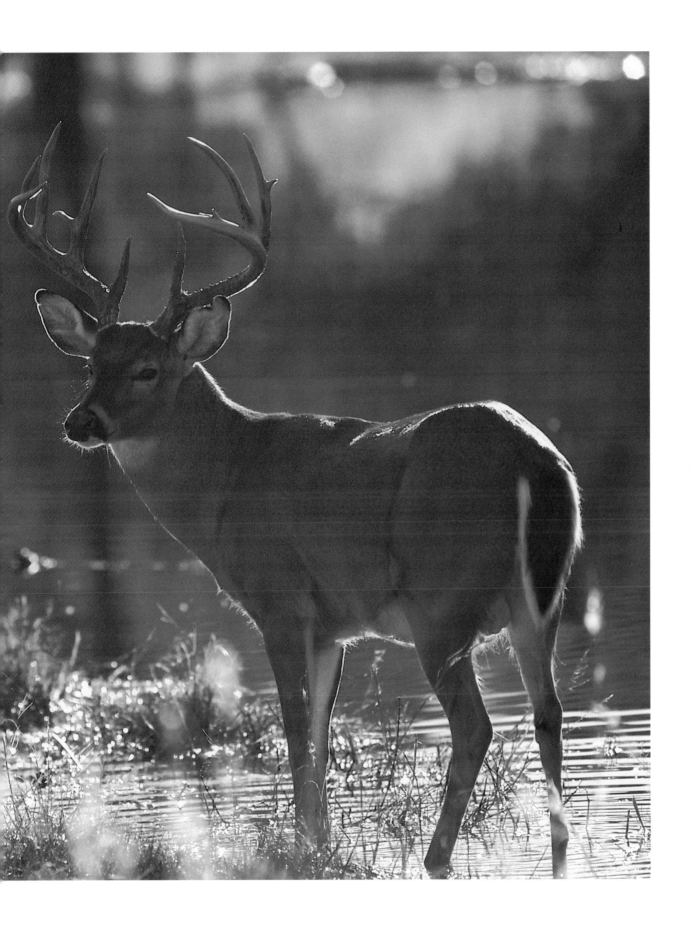

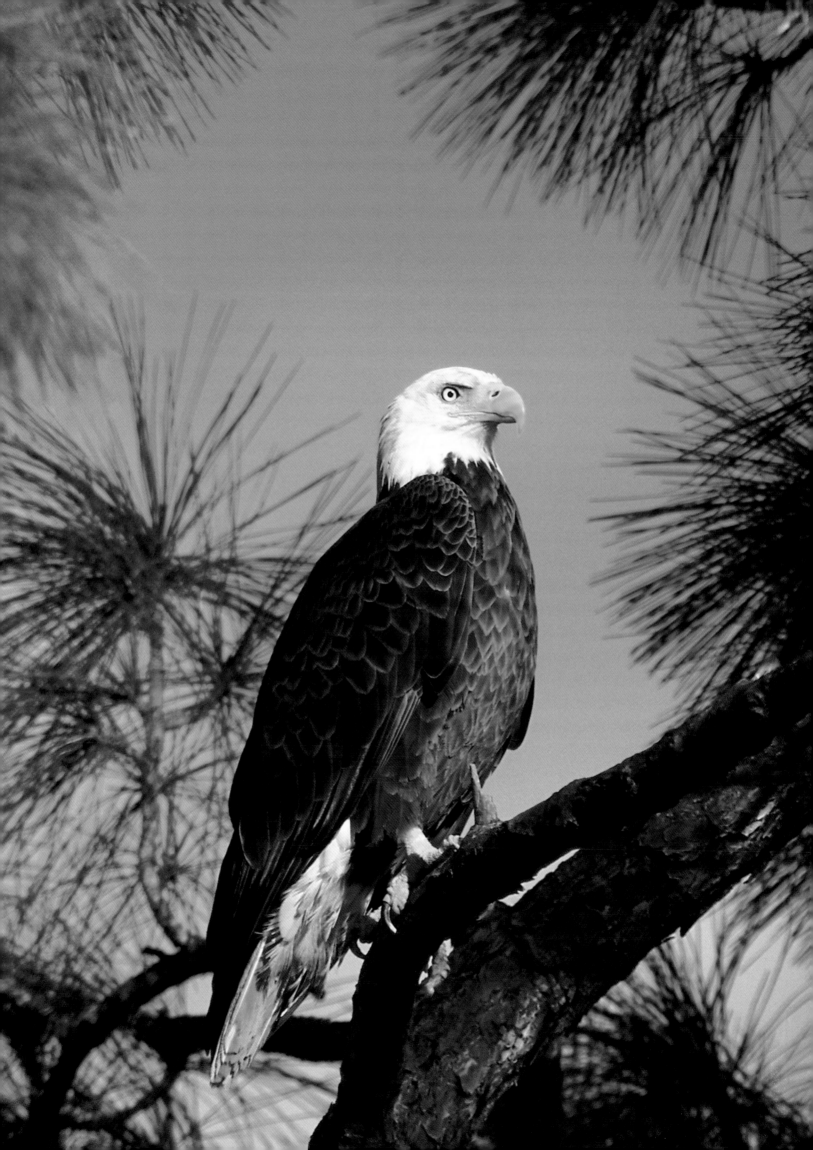

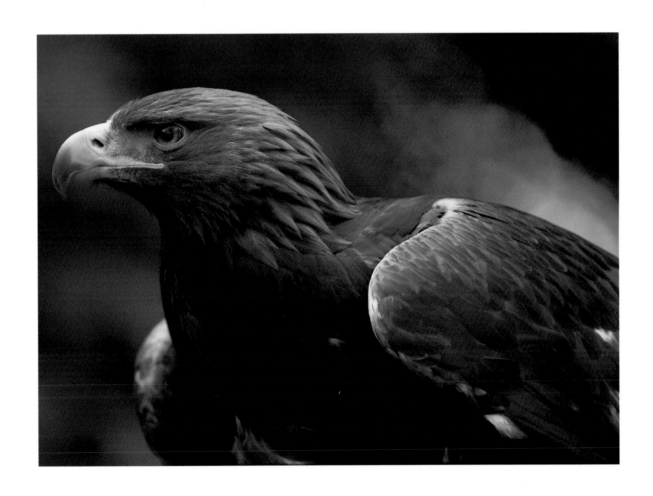

"When thou seest an eagle, thou seest a portion of genius;
lift up thy head!"

WILLIAM BLAKE

◄ Bald Eagle

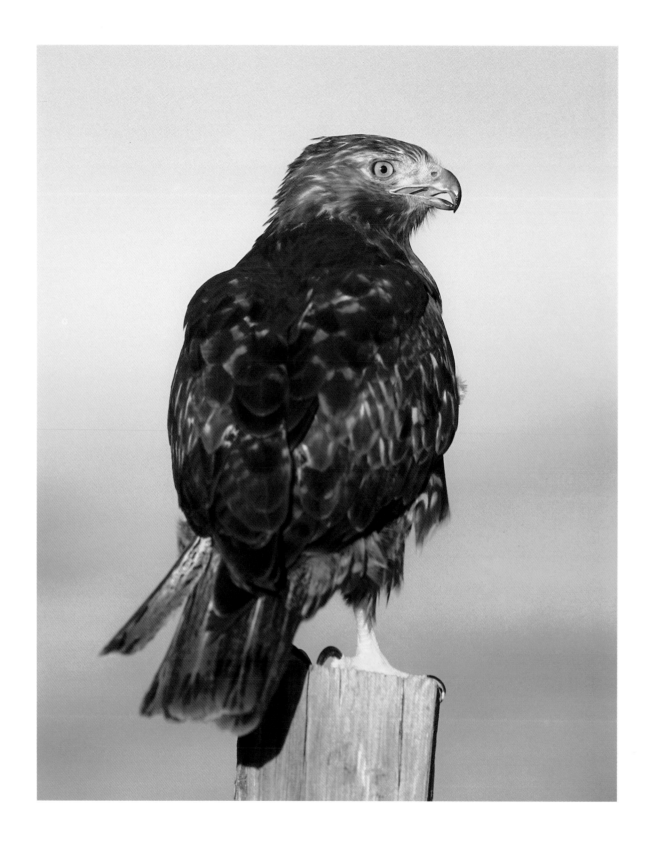

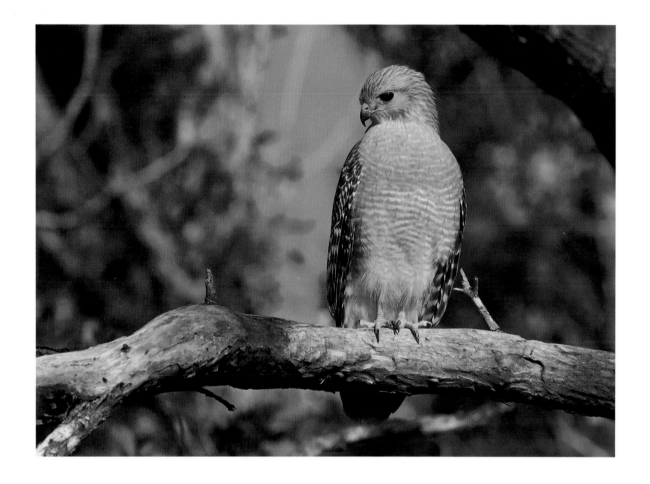

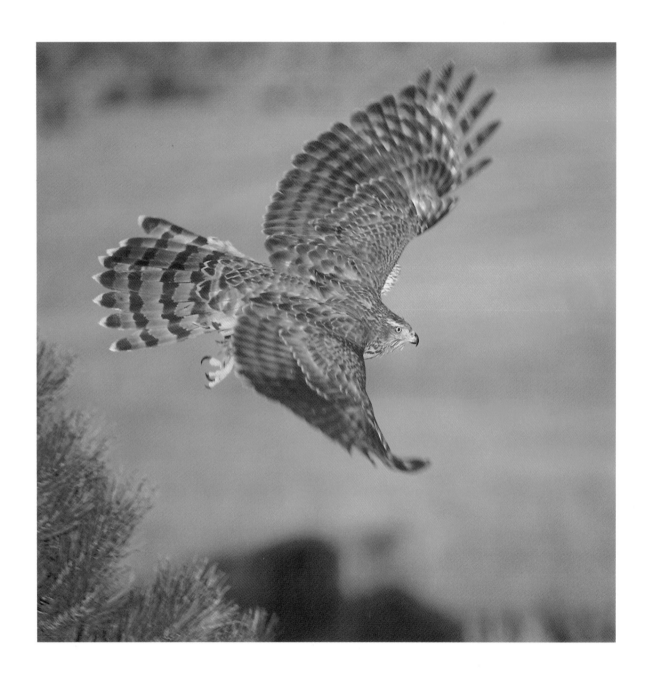

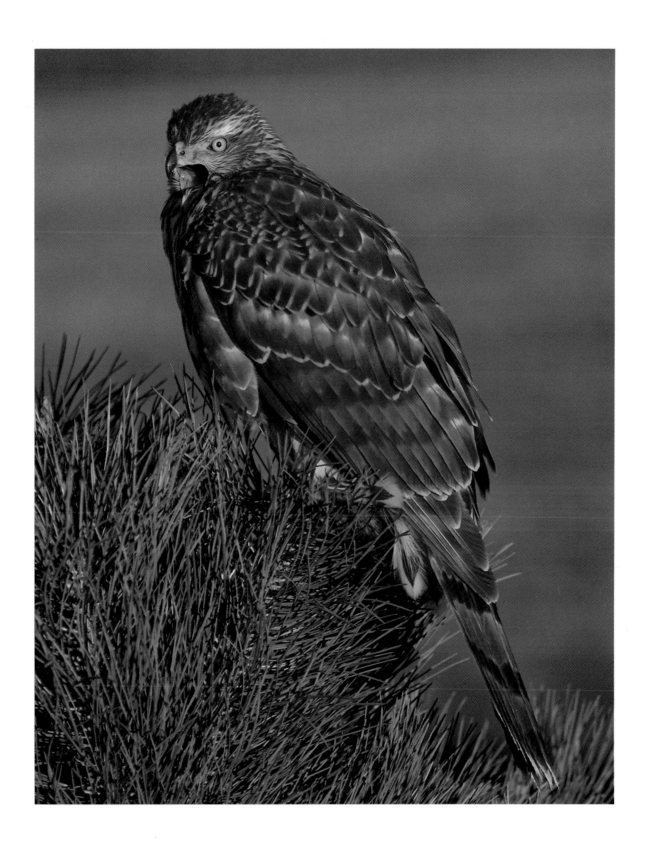

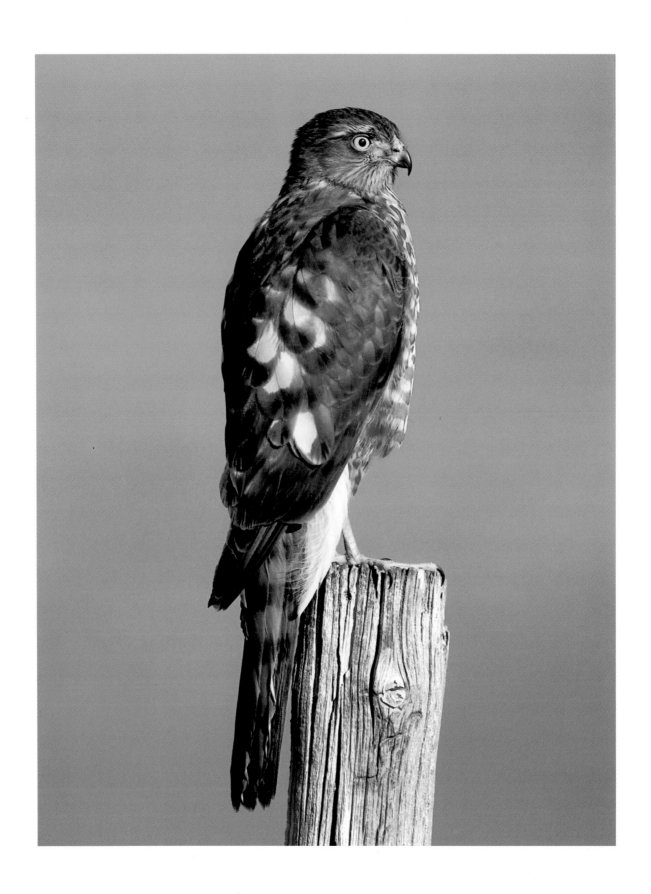

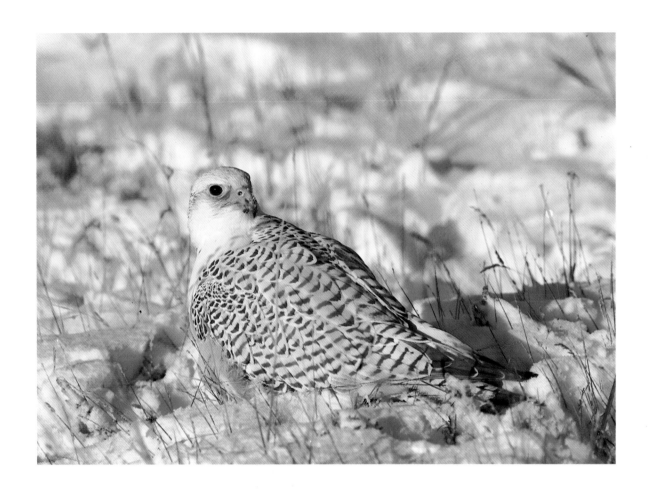

"Never does nature say one thing and wisdom another."

JUVENAL

44

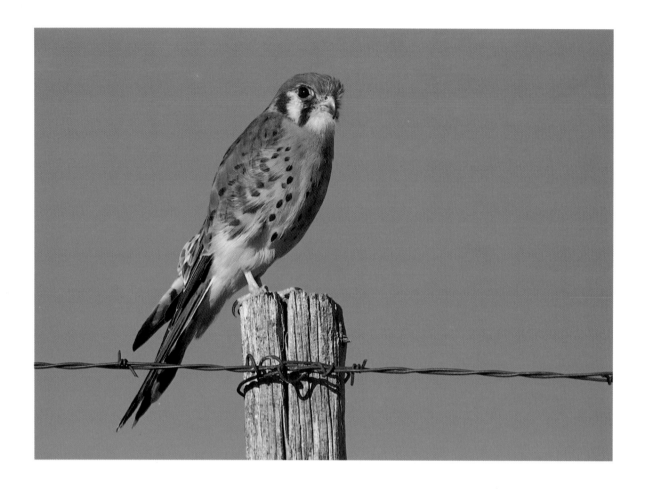

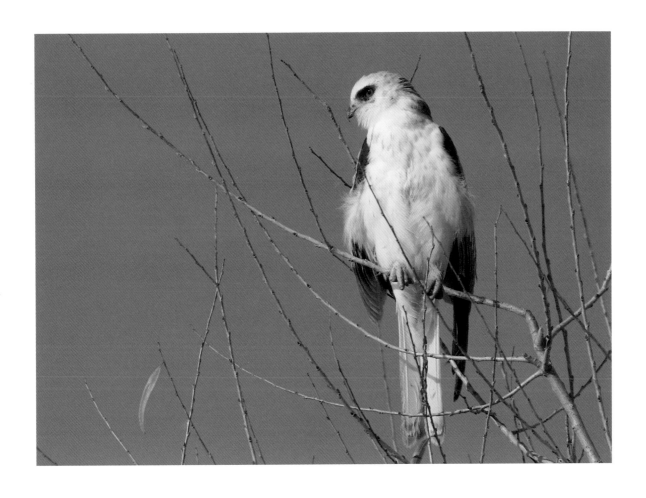

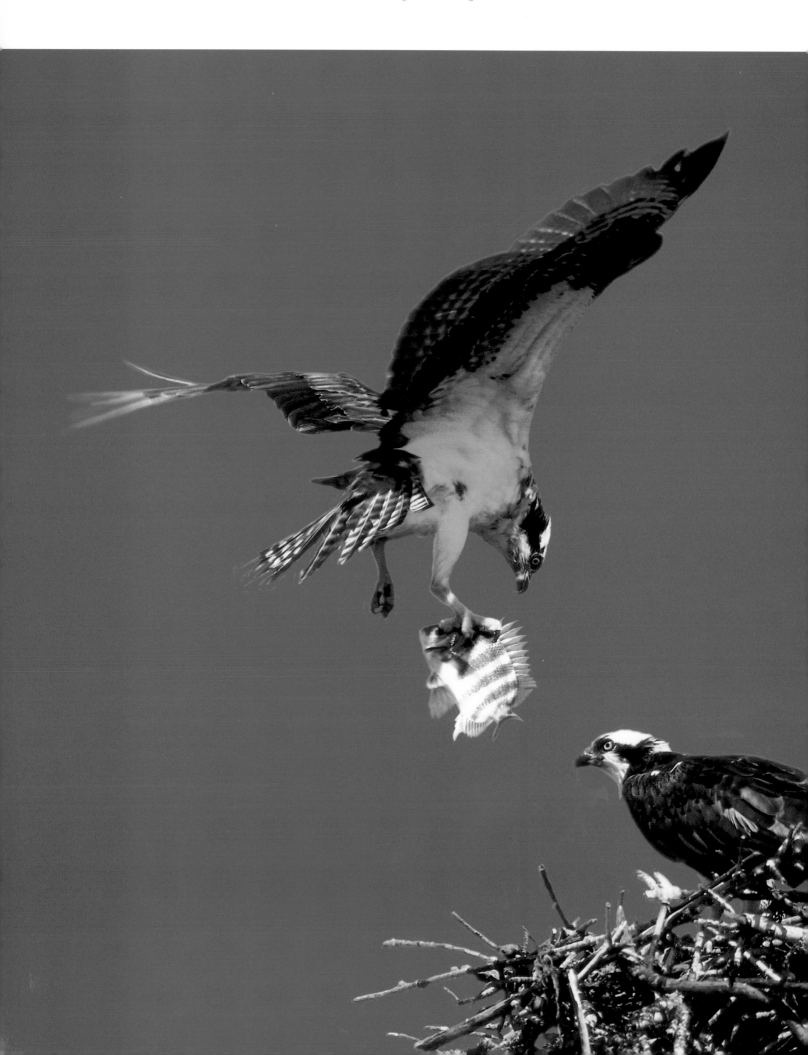

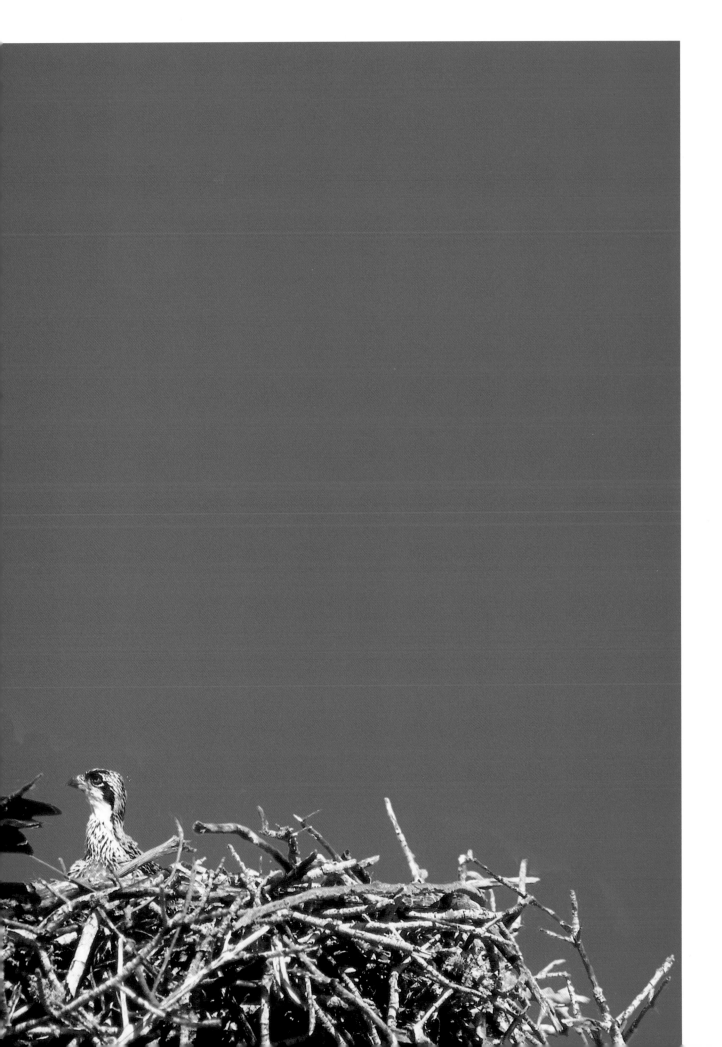

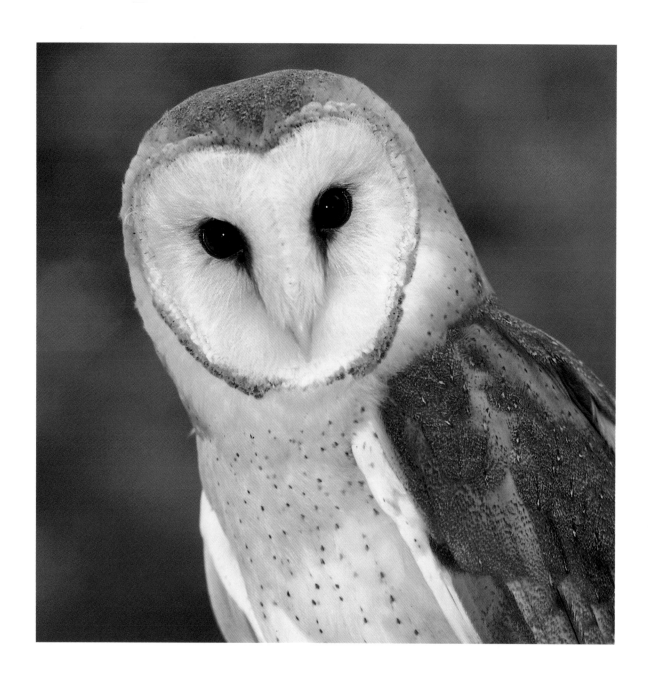

"*A* wise old owl, lived in an oak
The more he saw the less he spoke;
The less he spoke the more he heard;
Why can't we all be like that bird?"

EDWARD HERSEY RICHARDS

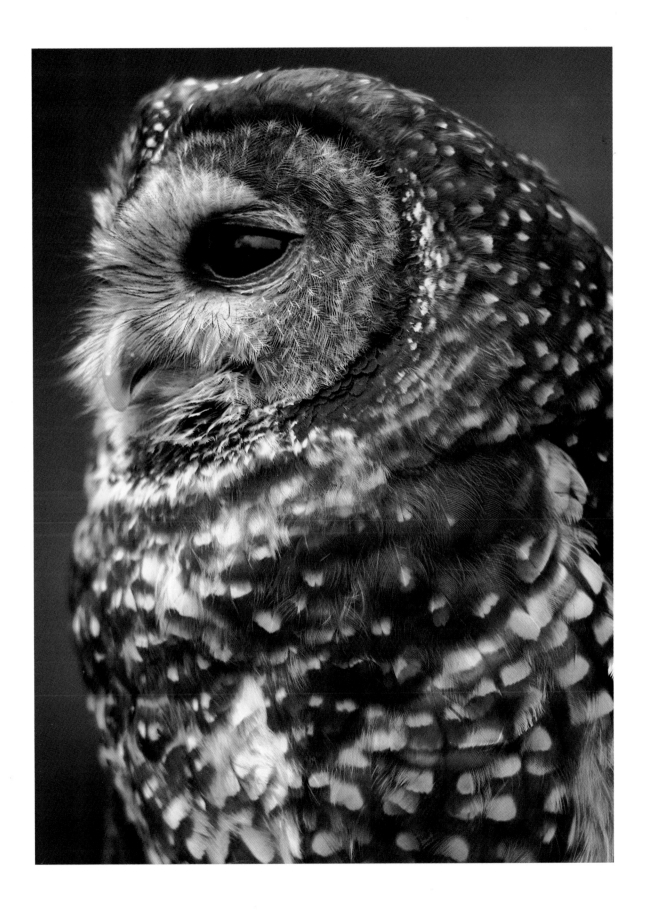

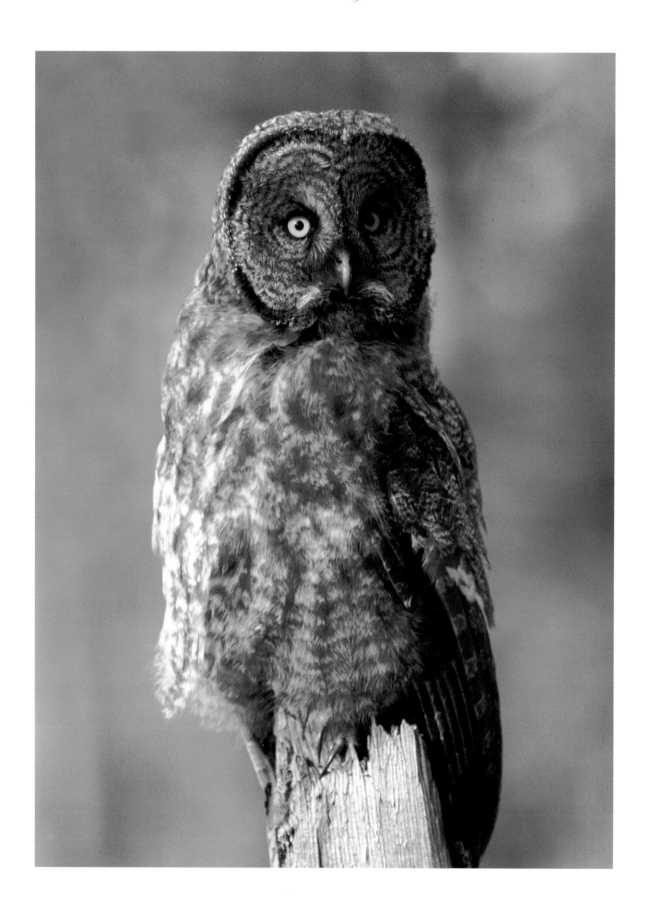

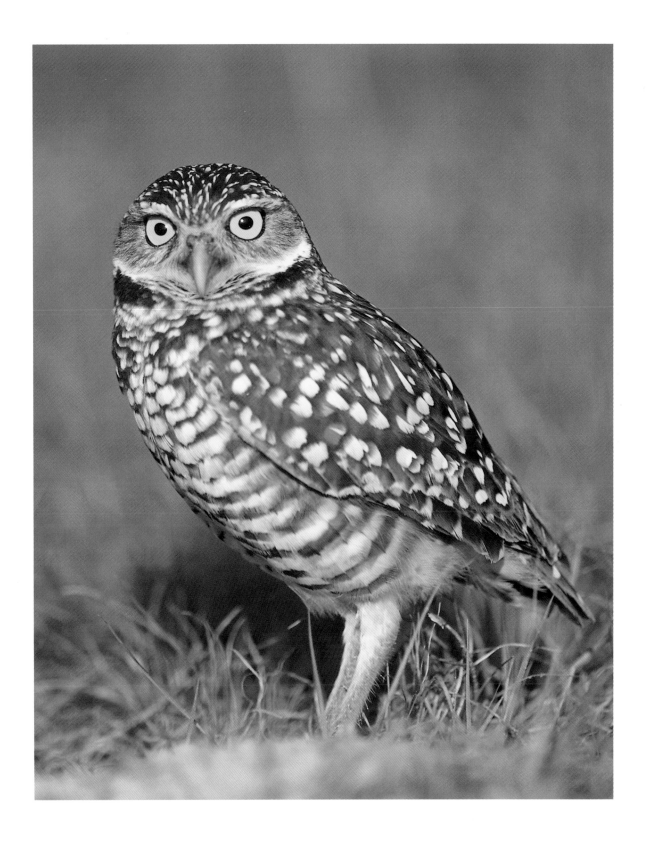

52

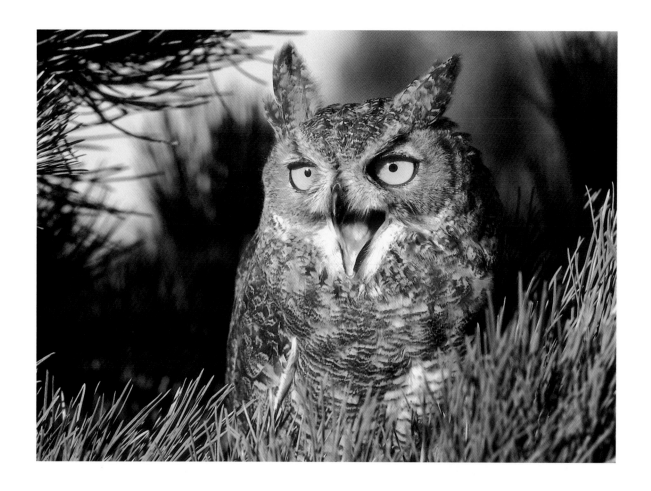

"*O*' *for the voices of animals!*"

WALT WHITMAN

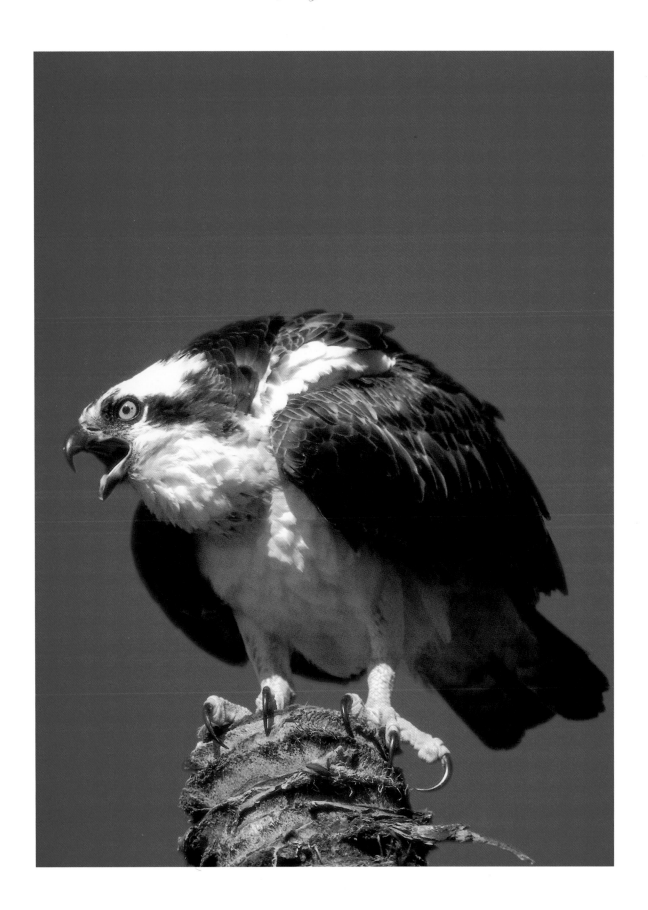

"Come forth into the light of things, let nature be your teacher."

WILLIAM WORDSWORTH

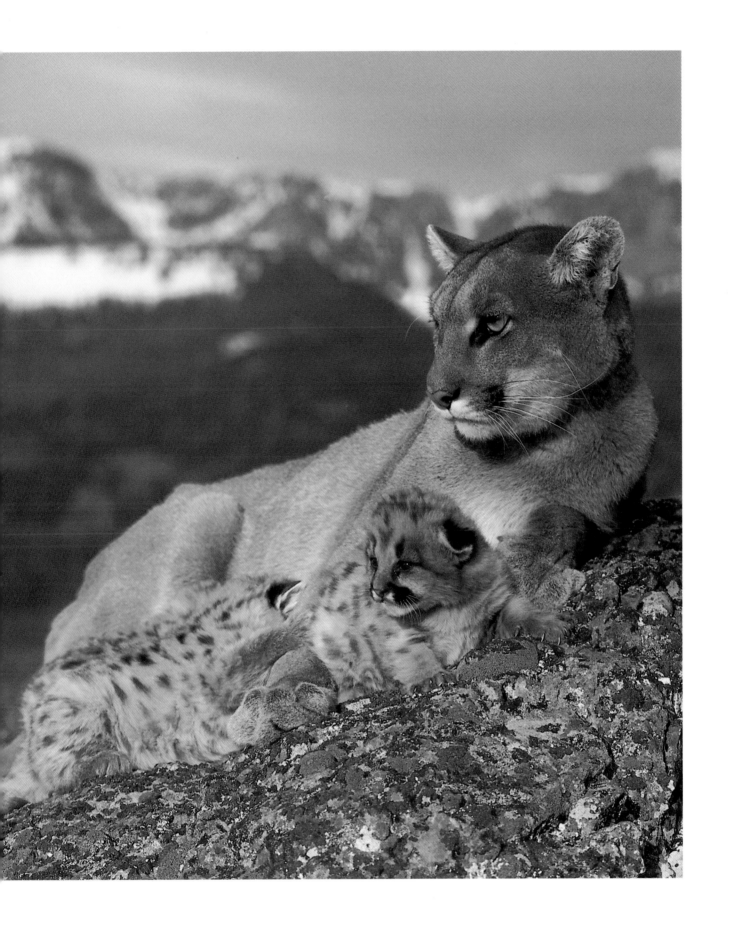

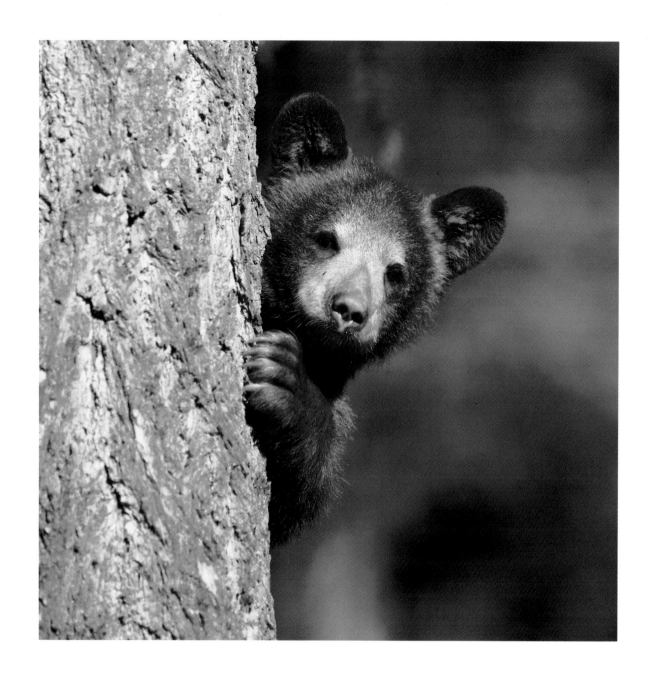

Grizzly Bear Cub ▶

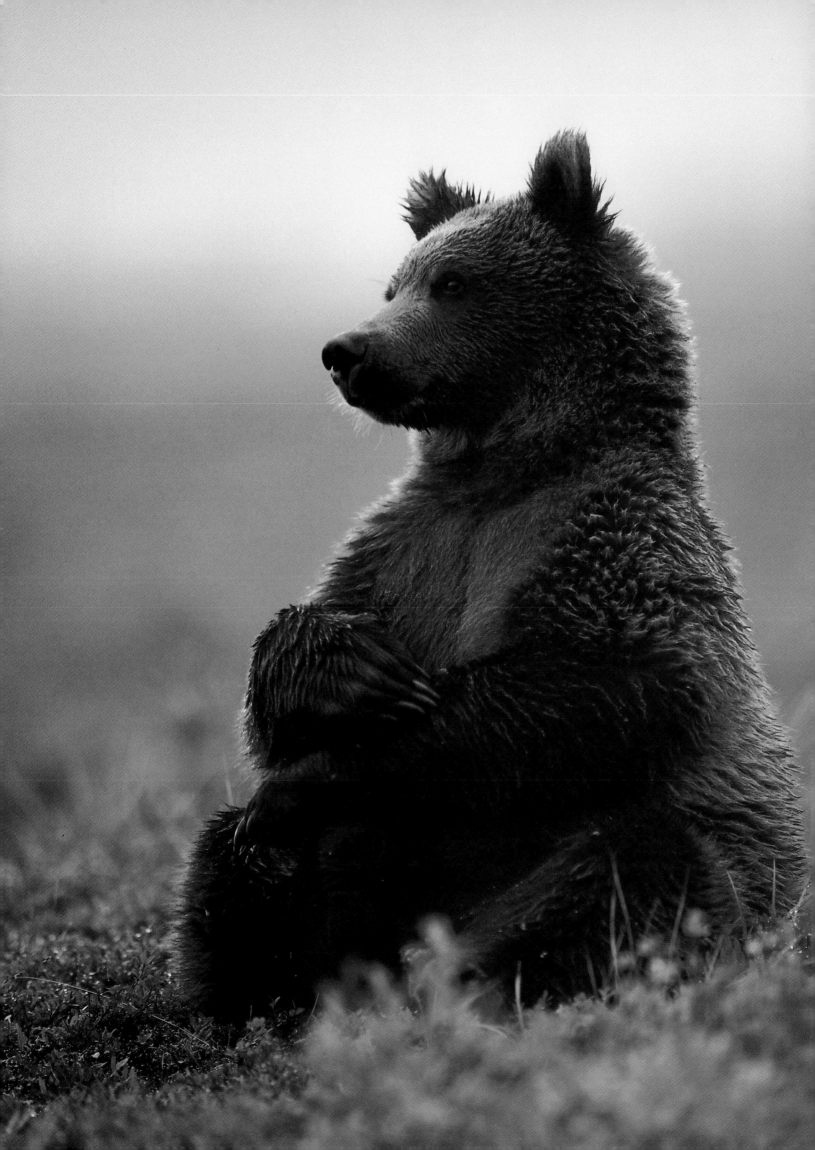

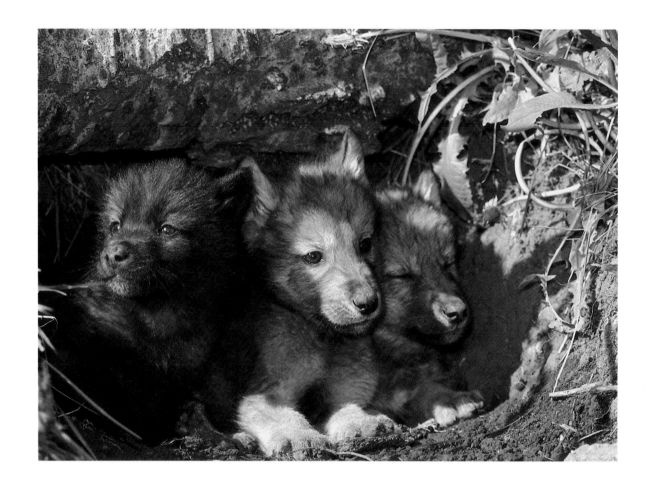

59

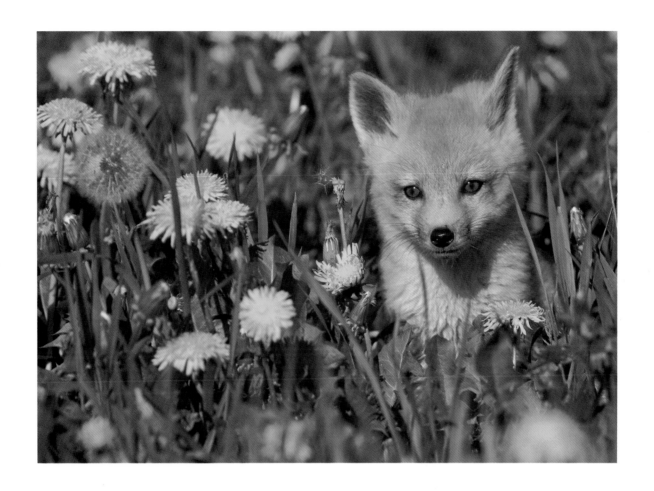

"Every baby born into the world is a finer one than the last."

CHARLES DICKENS

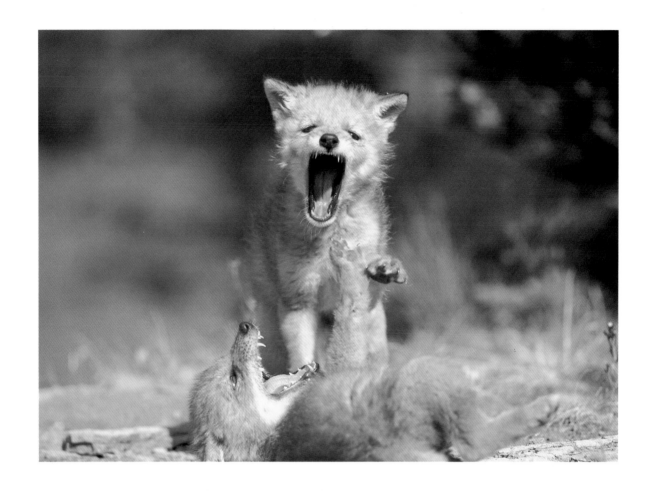

"*In wilderness I sense the miracle of life, and behind it our scientific accomplishments to fade to trivia.*"

CHARLES LINDBERGH

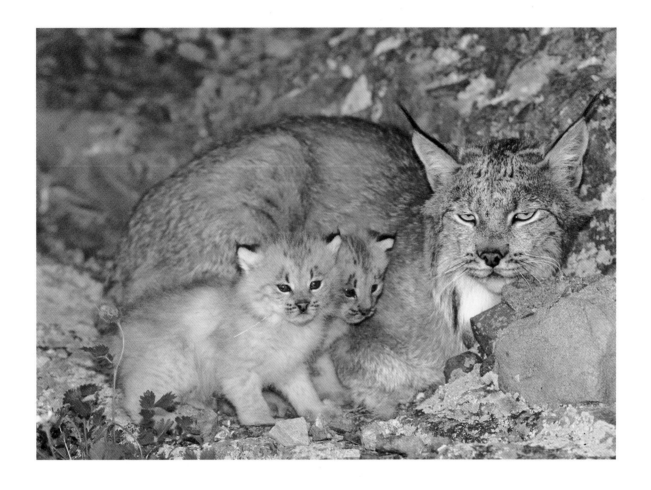

62

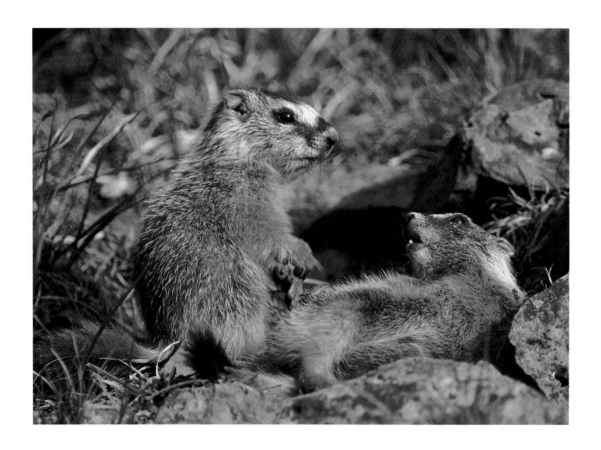

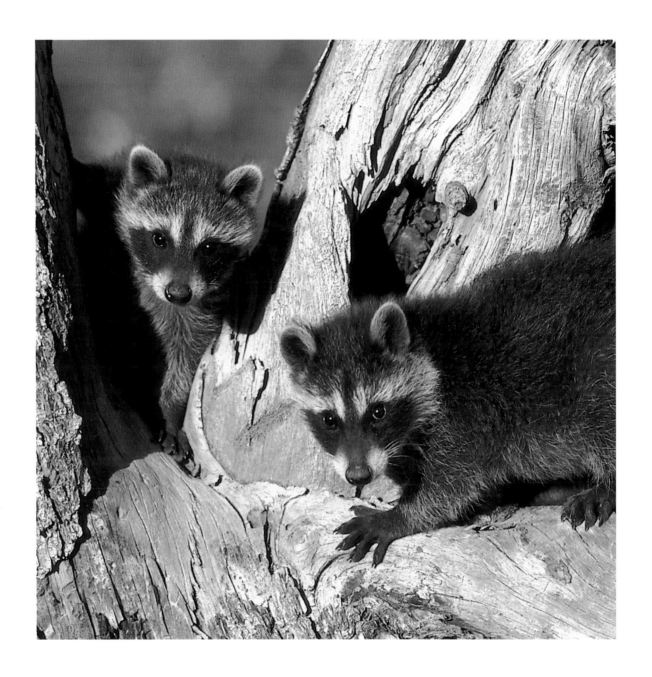

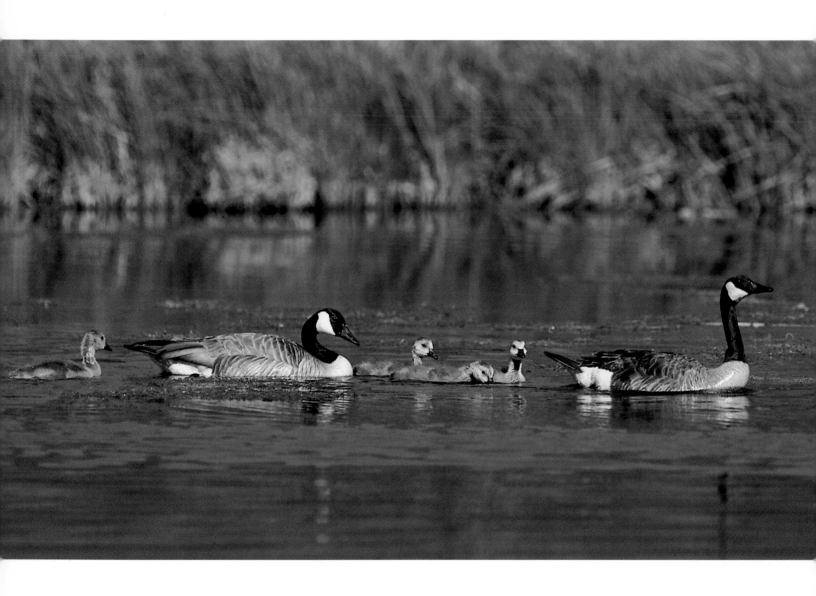

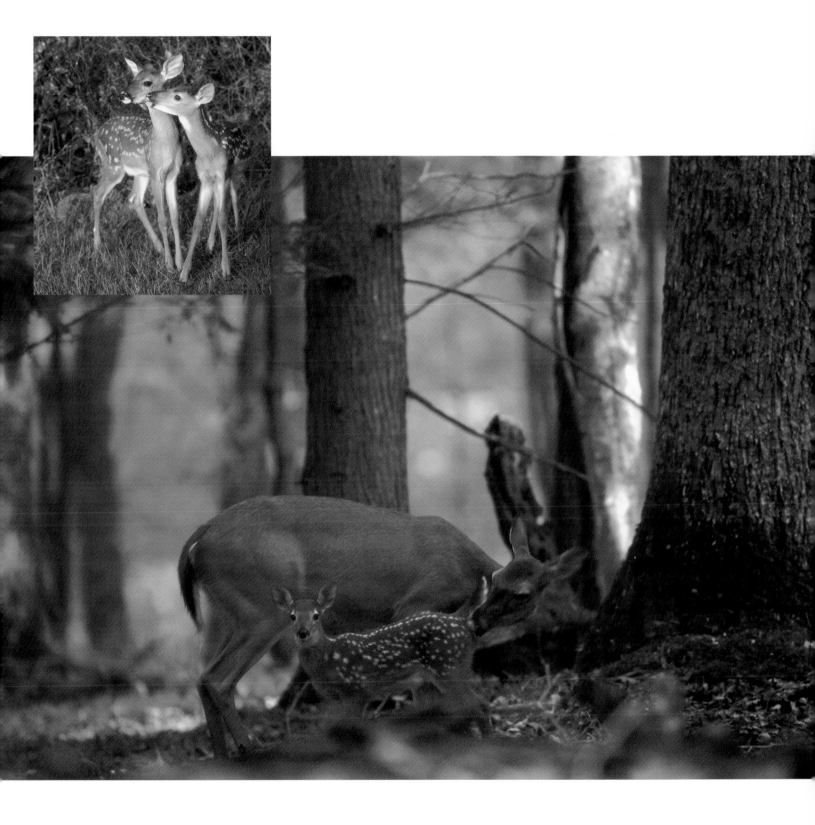

"*For I'd rather be thy child and pupil, in the forest wild,*
Than be the king of men elsewhere."

HENRY DAVID THOREAU

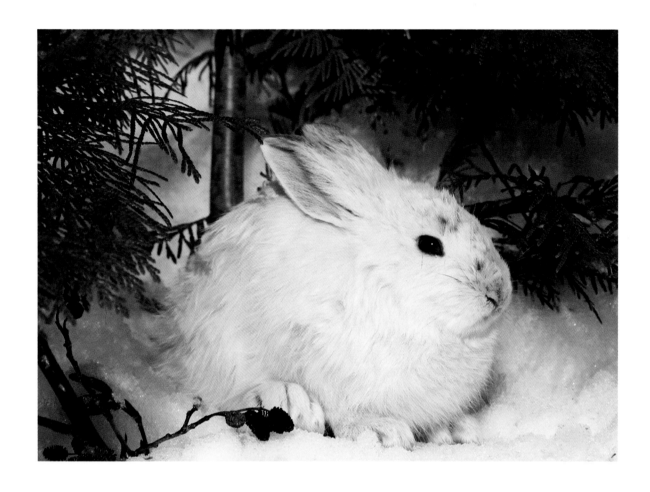

"*Nature does nothing in vain.*"

SIR THOMAS BROWNE

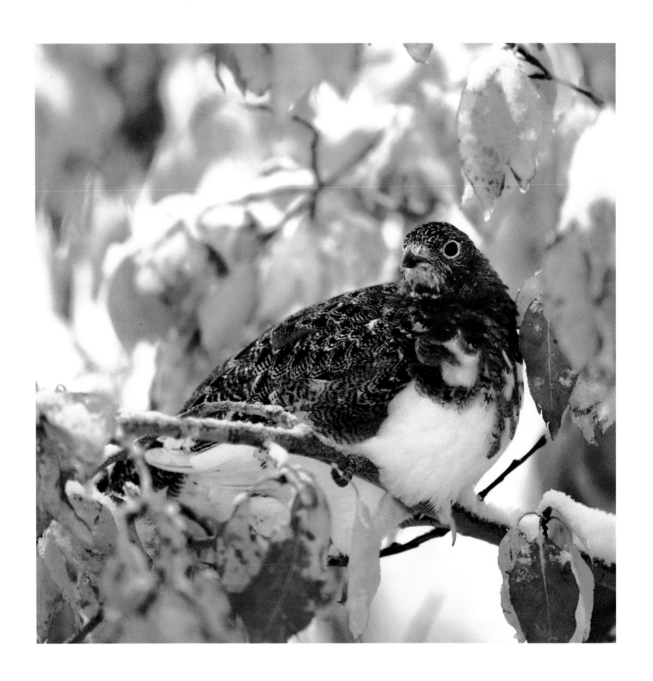

Mallard Duck

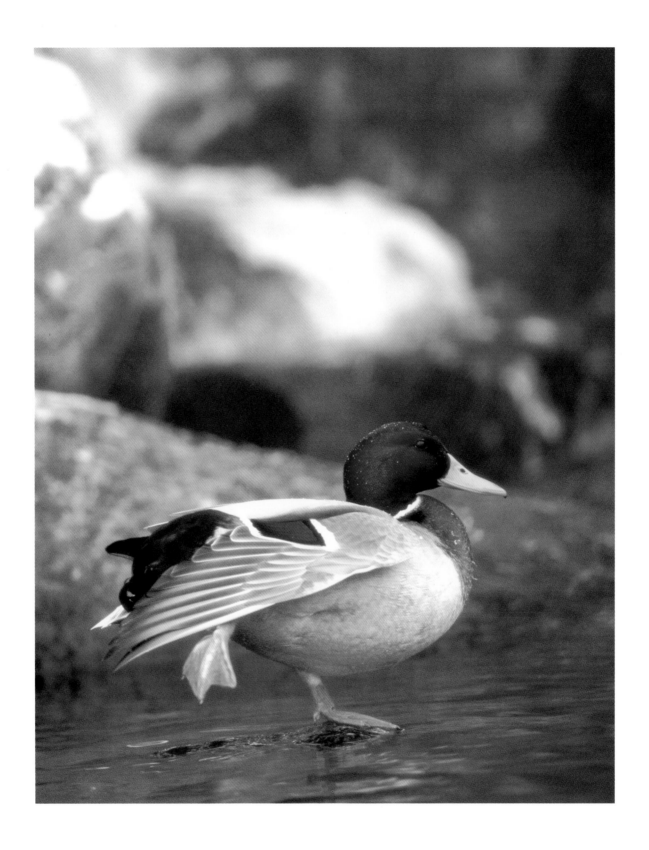

69

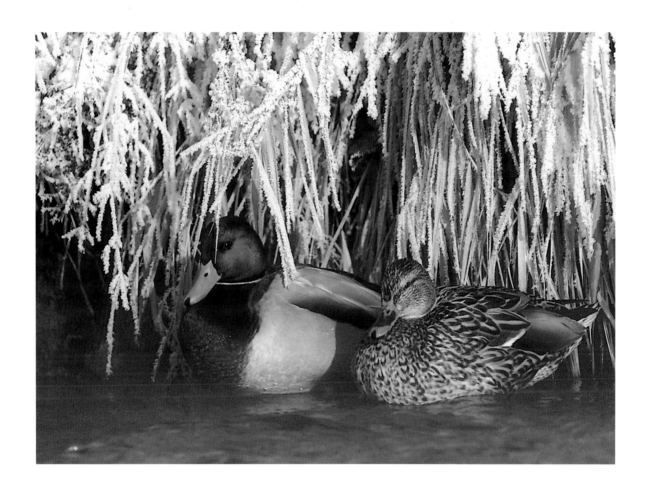

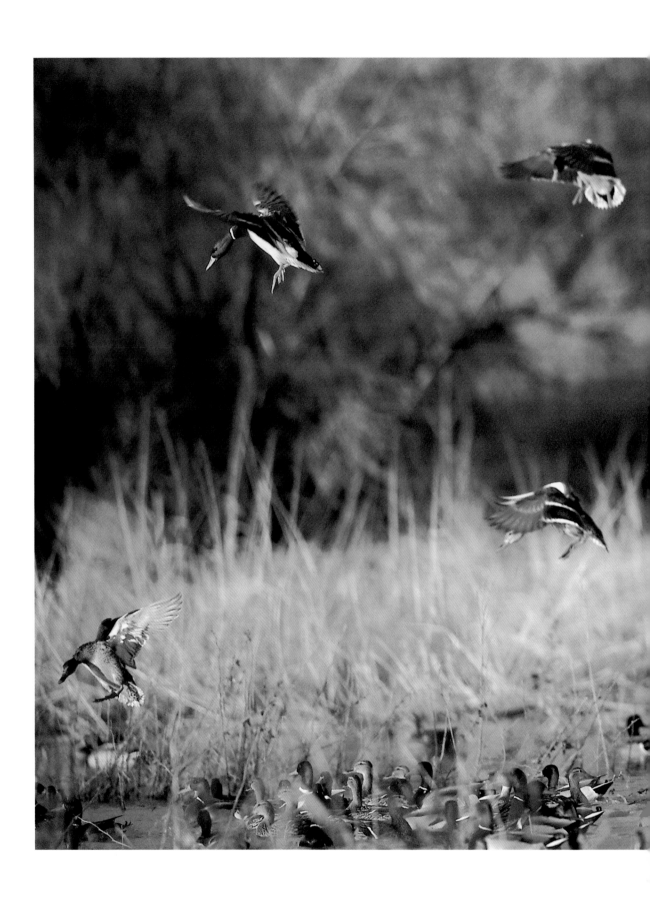

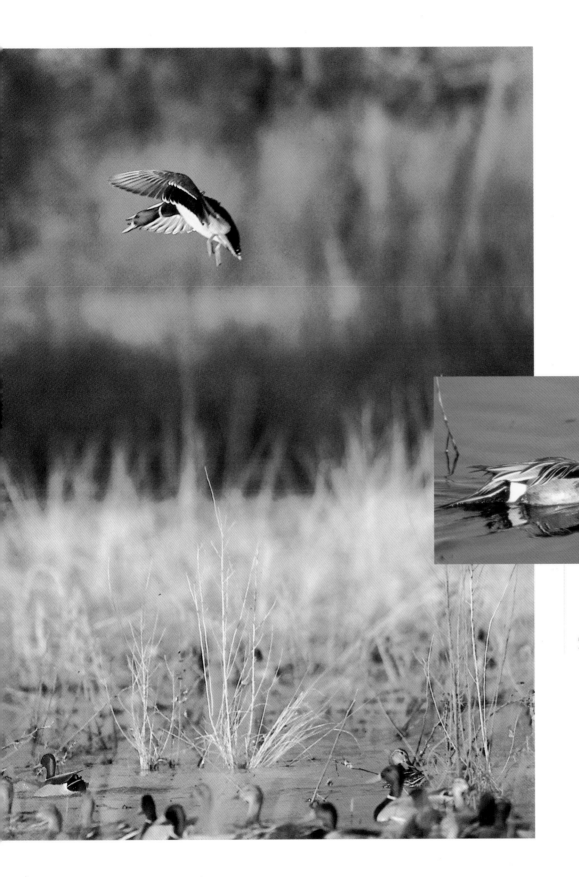

Northern Pintail

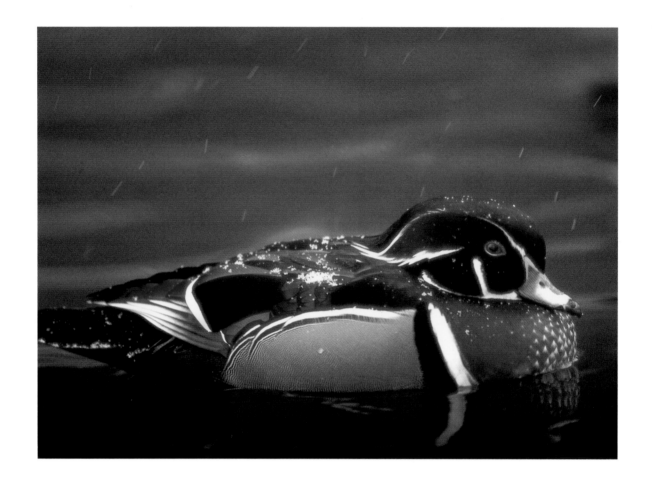

73

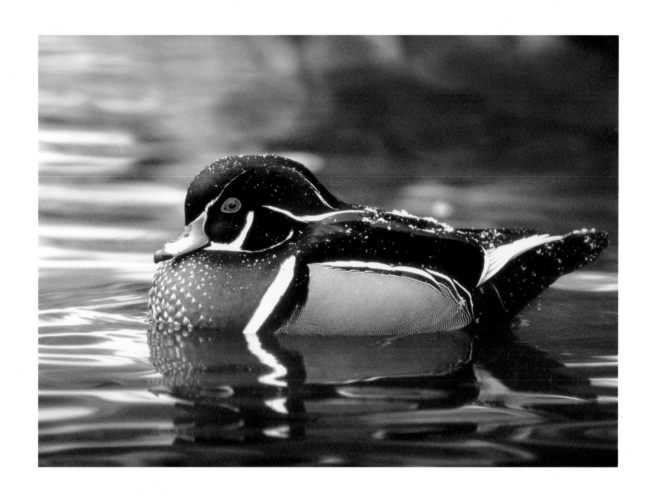

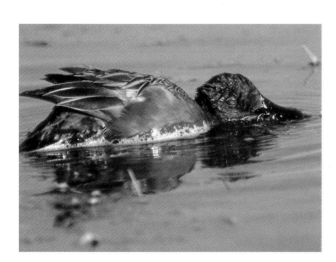

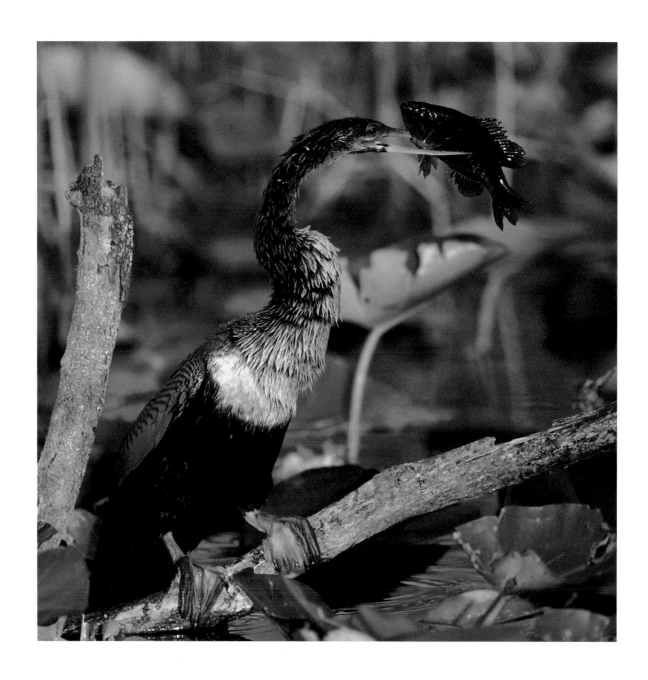

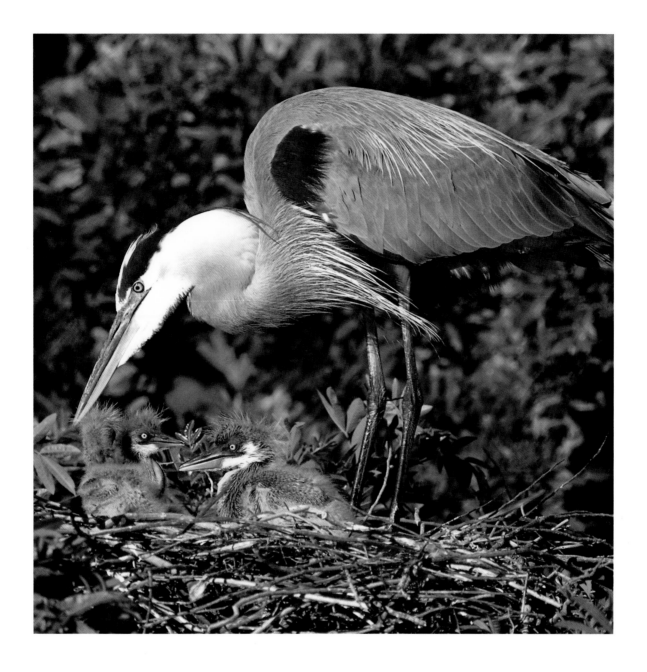

Mallard Ducks

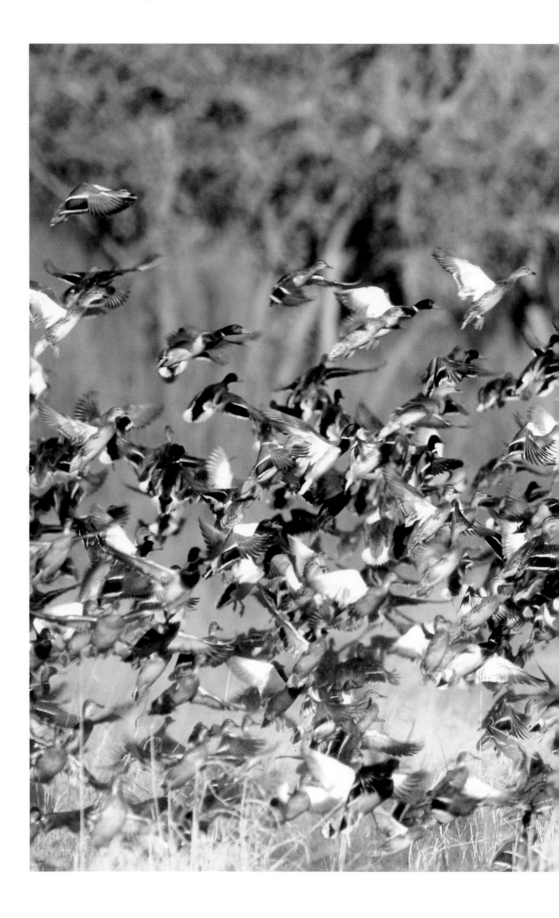

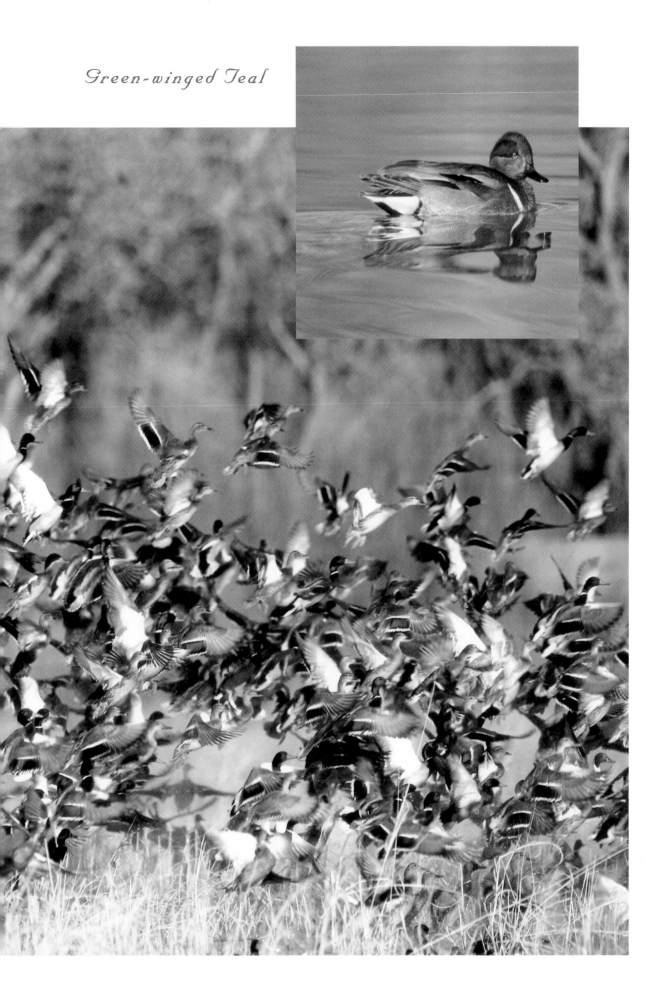

Green-winged Teal

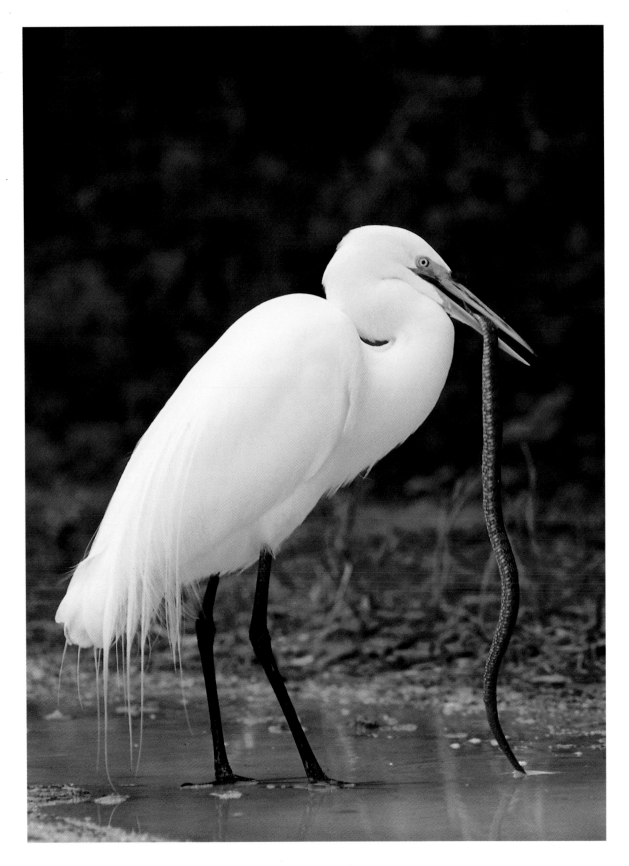

"In nature there are neither rewards nor punishments –
there are consequences."

ROBERT G. INGERSOIL

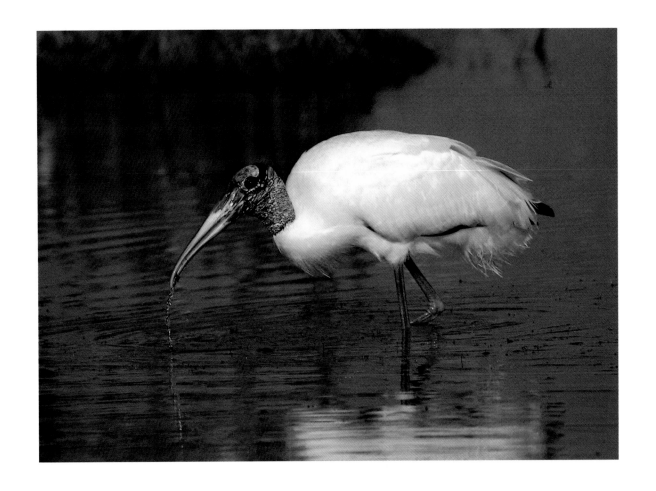

"Nature thrives on patience; man on impatience."

PAUL BOESE

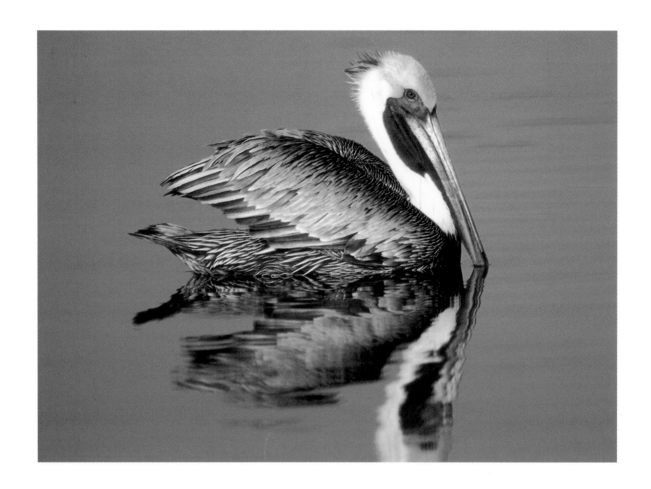

81

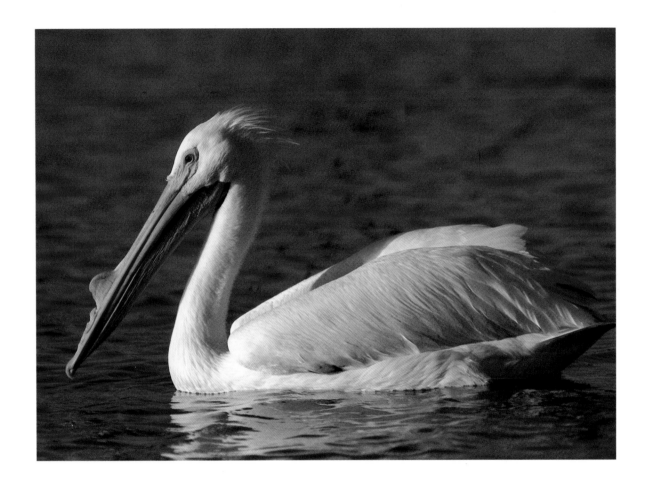

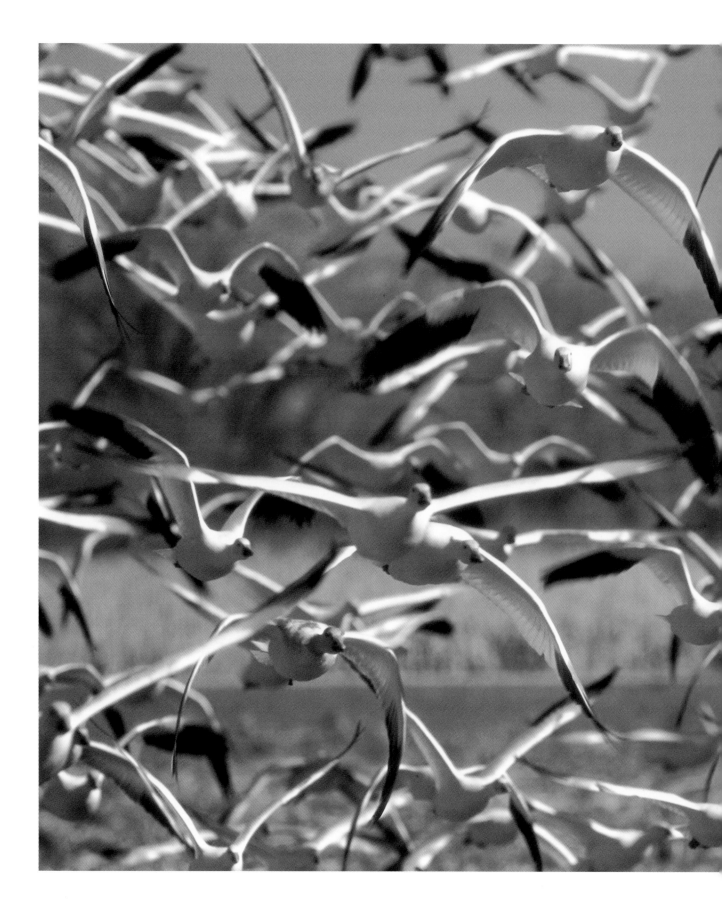

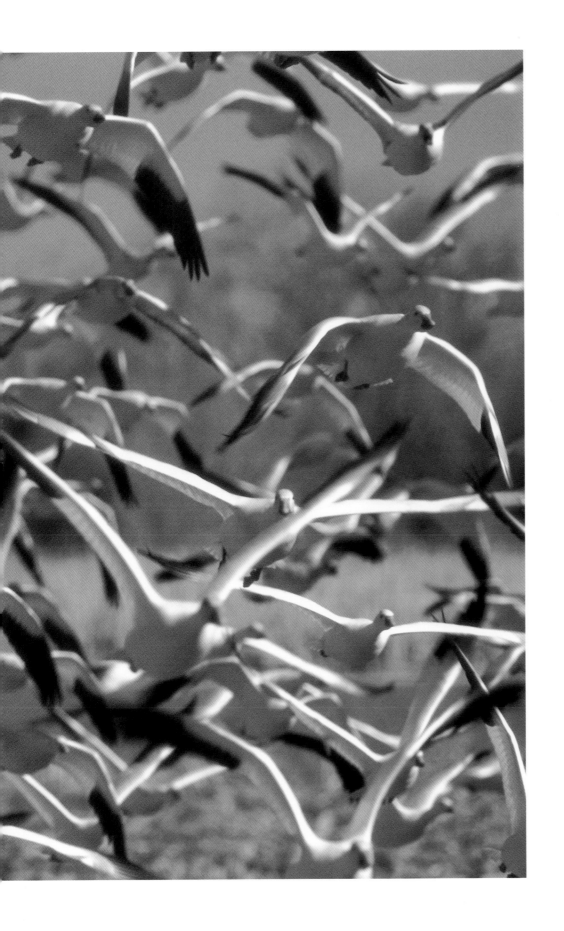

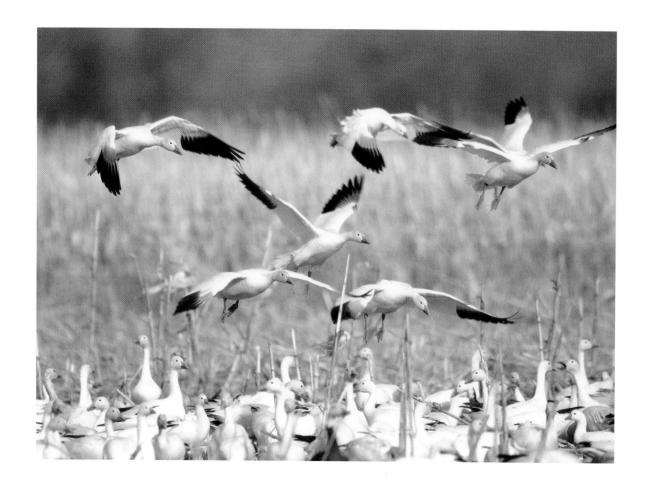

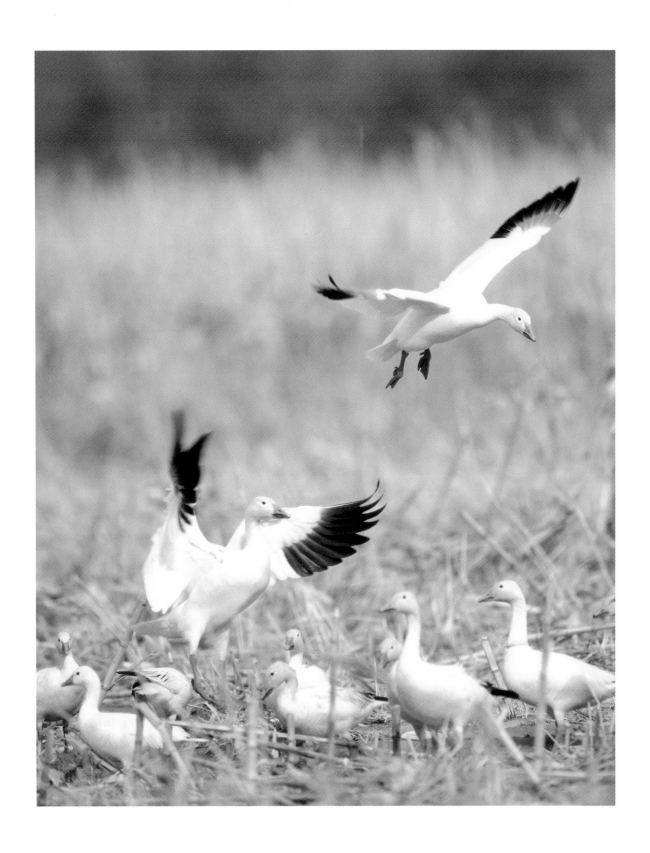

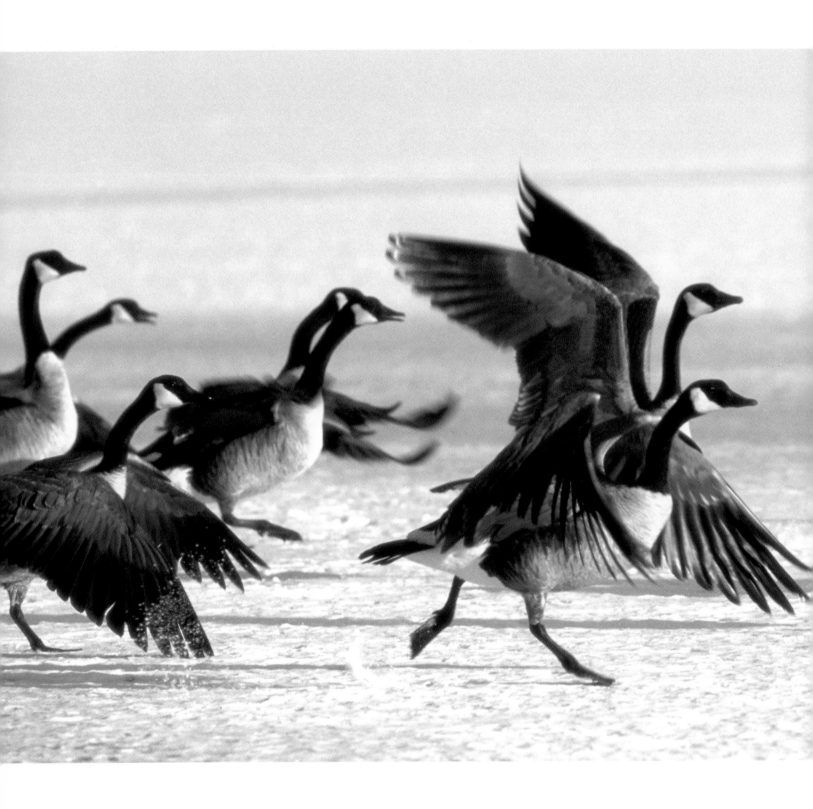

"*All of the animals except man know that the principle business of life is to enjoy it.*"

ANNONYMOUS

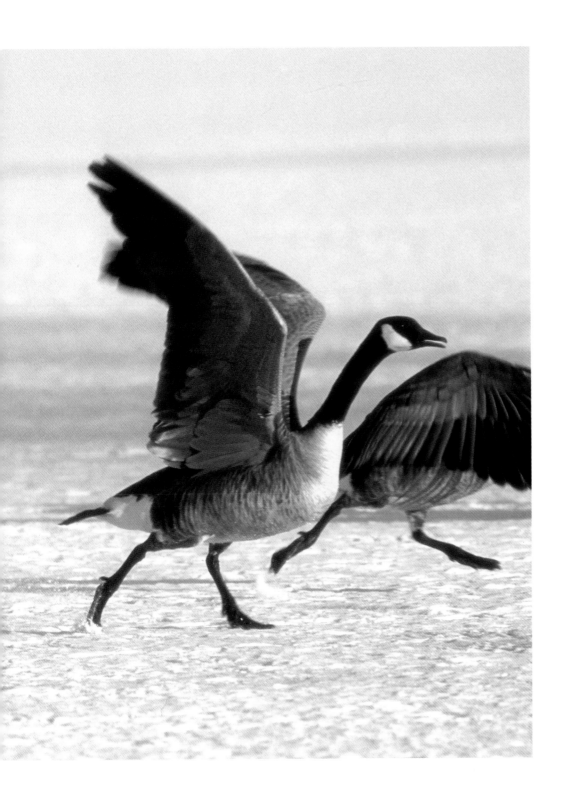

88

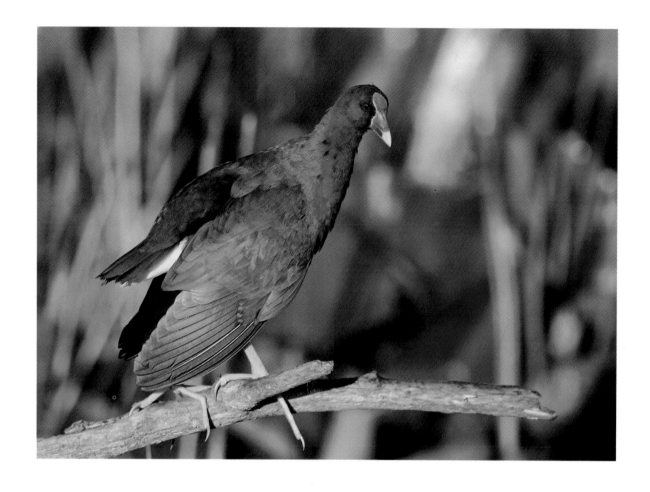

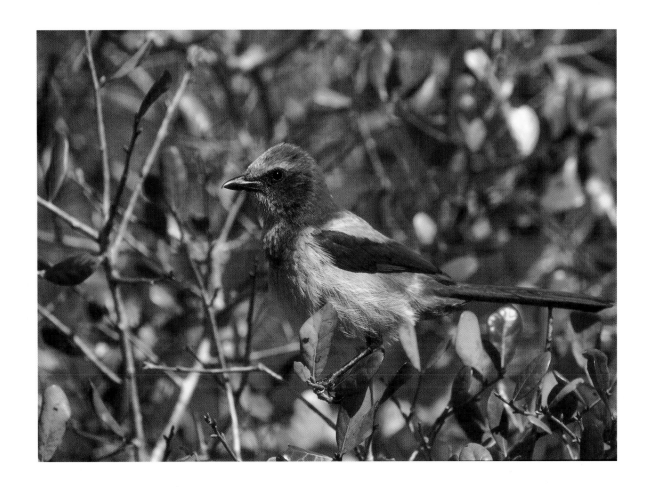

"*A kiss of the sun for pardon, the song of birds for mirth.*"

Dorothy Gurney

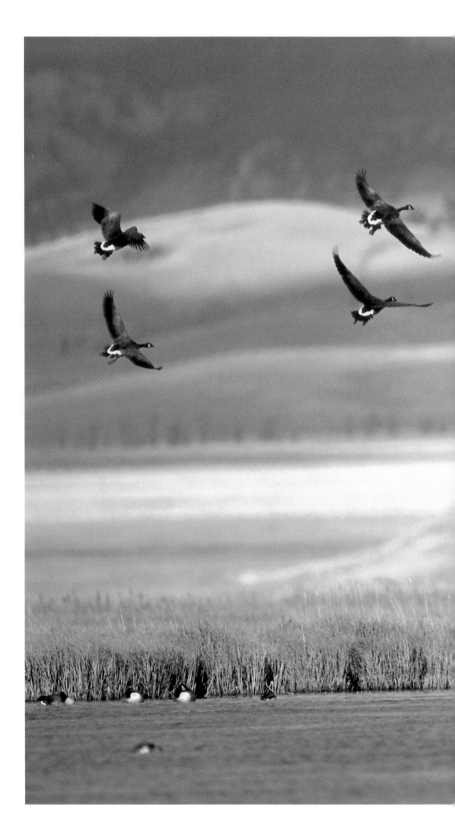

"All nature is but art... ."

Pope, *Essay on Man,* Epis. i, 1.289

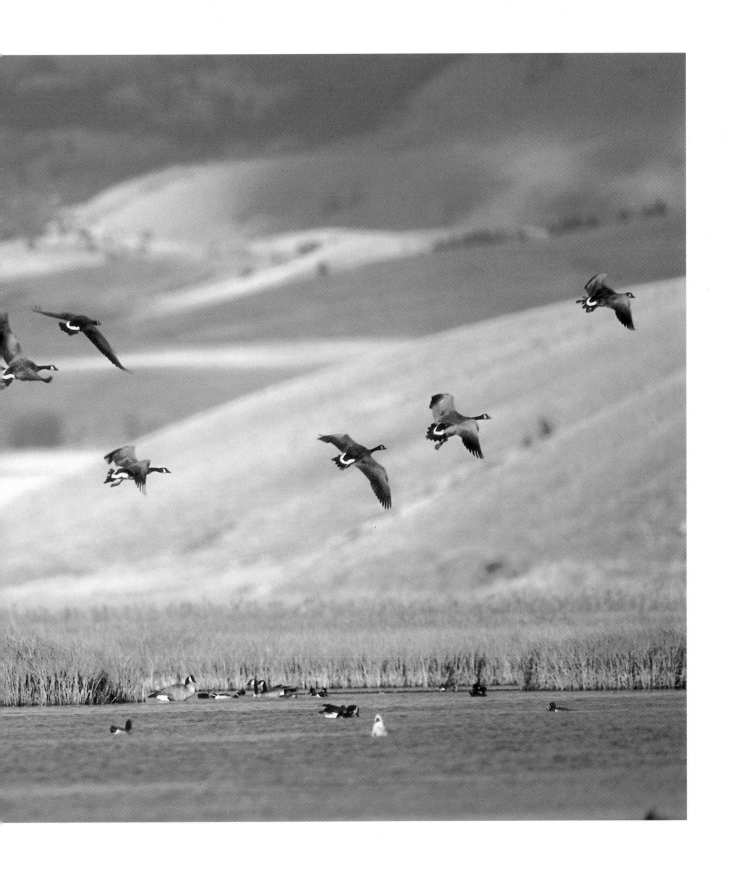

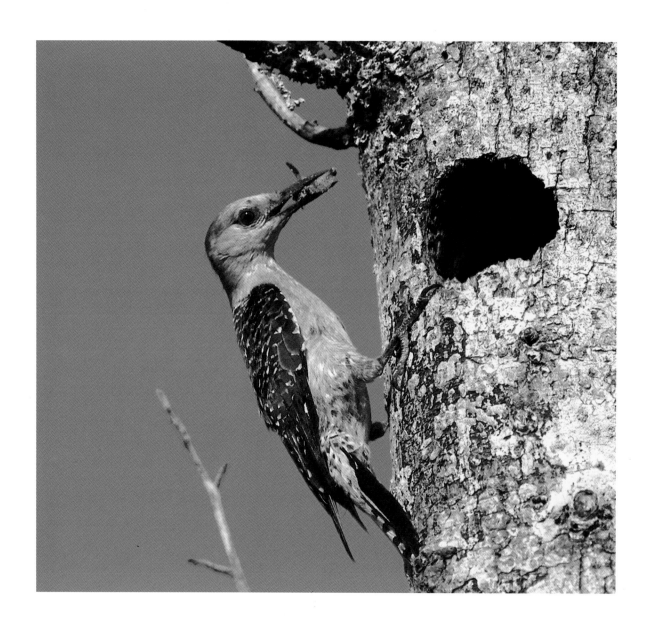

"*Nature will bear the closest inspection.
She invites us to lay our eye level with her smallest leaf,
and take an insect view of it's plain.*"

HENRY DAVID THOREAU

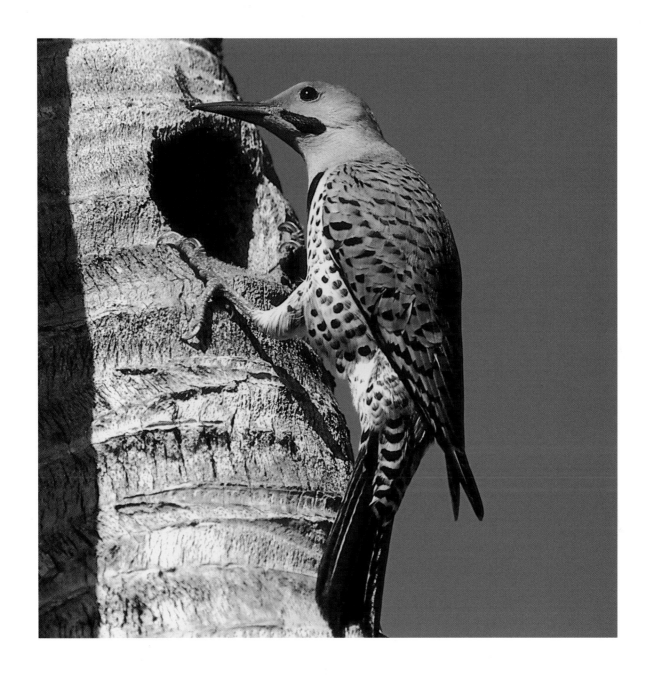

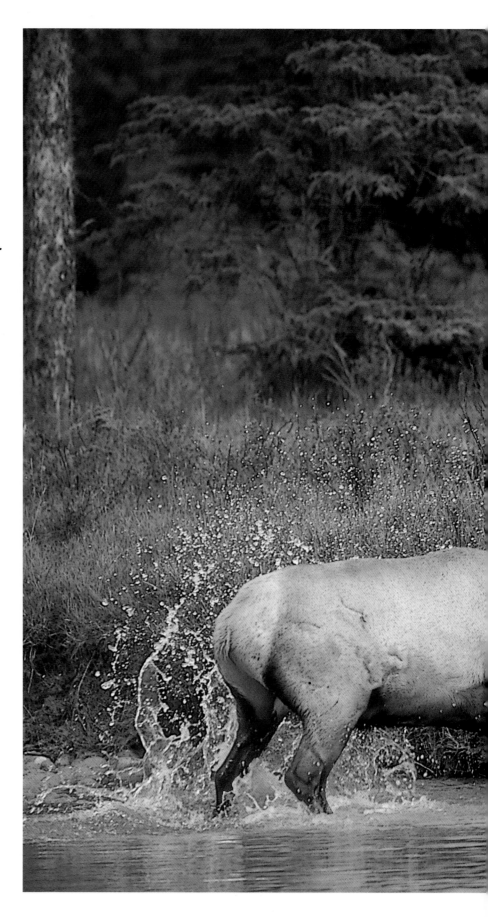

"*It was a splendid fight. The great beasts faced each other with lowered horns, the manes that covered their thick necks and the hair on their shoulders bristling and erect. Then they charged furiously, the crash of the meeting antlers resounding through the valley.*"

THEODORE ROOSEVELT

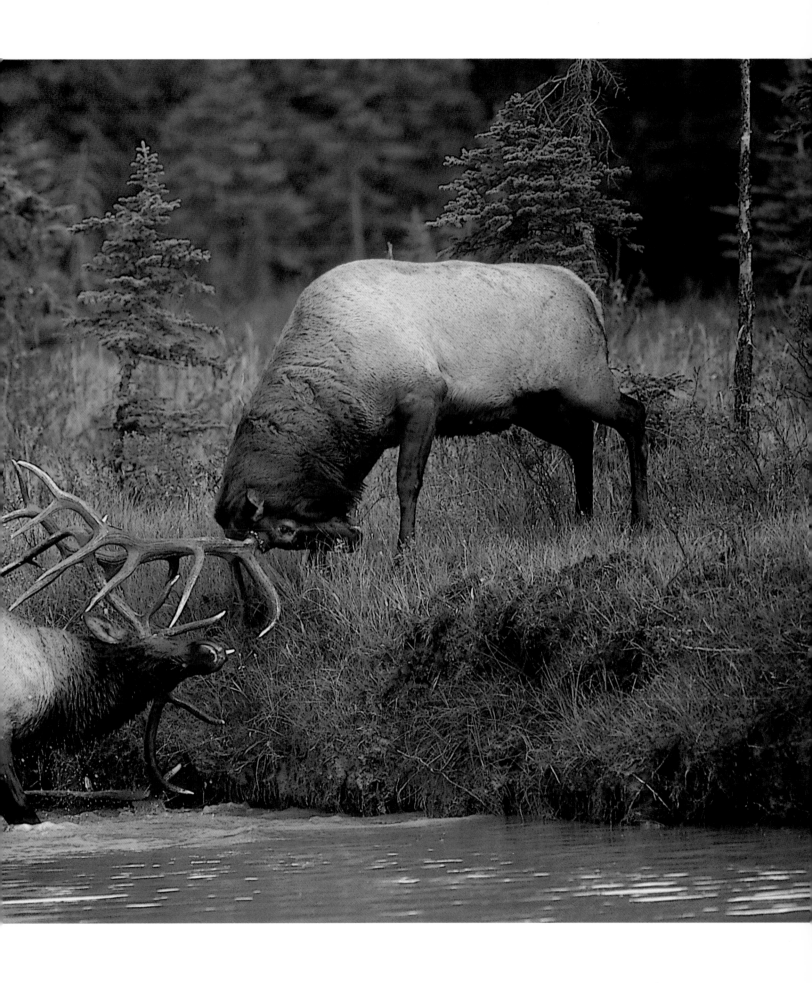

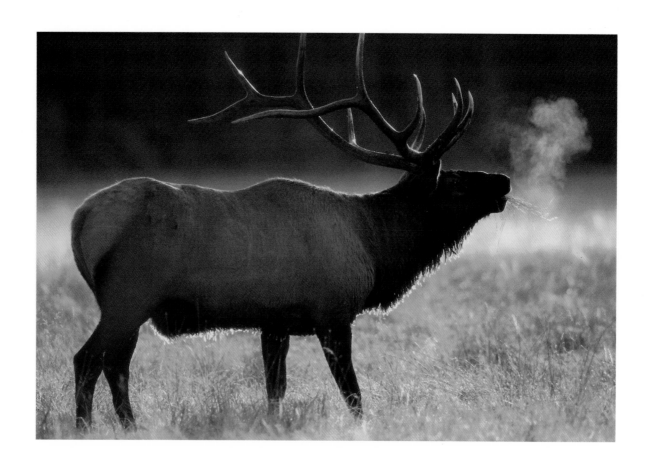

"Nature is not governed except by obeying her."

FRANCIS BACON

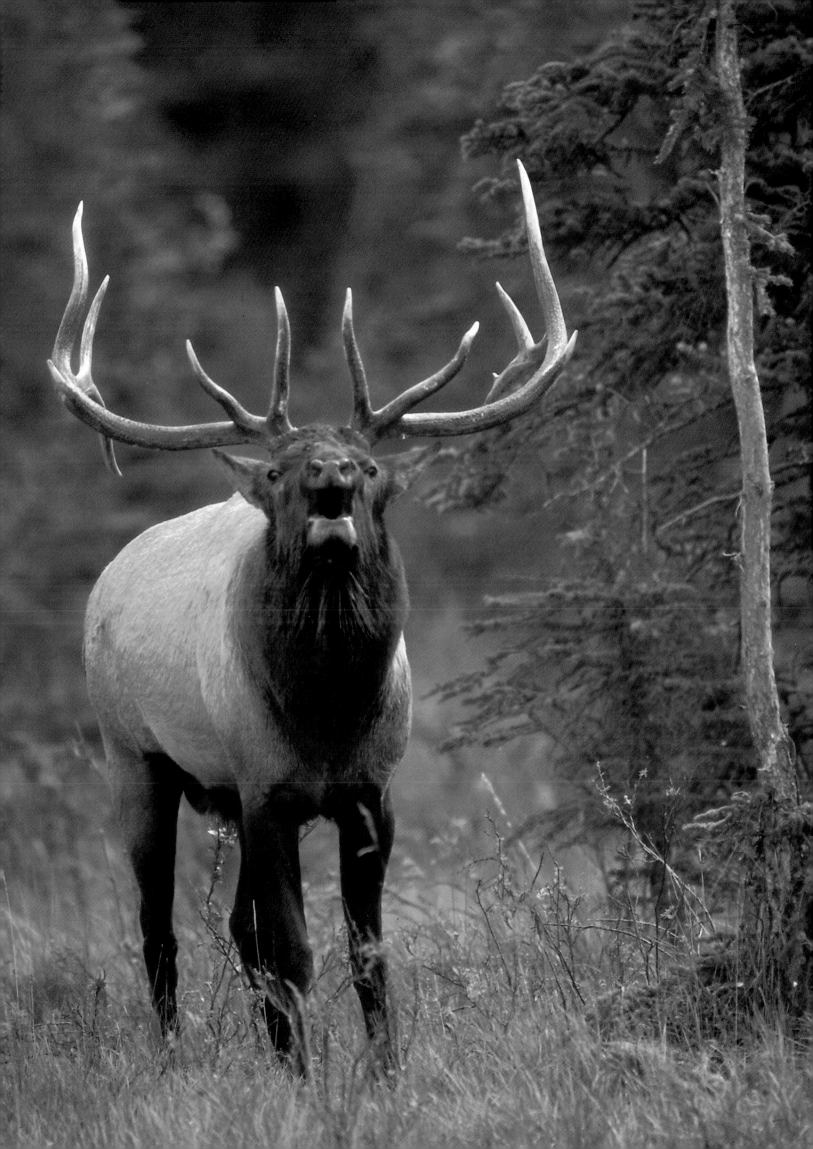

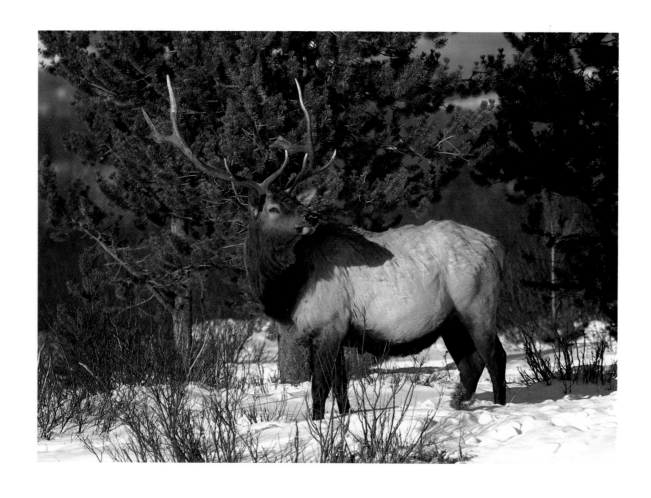

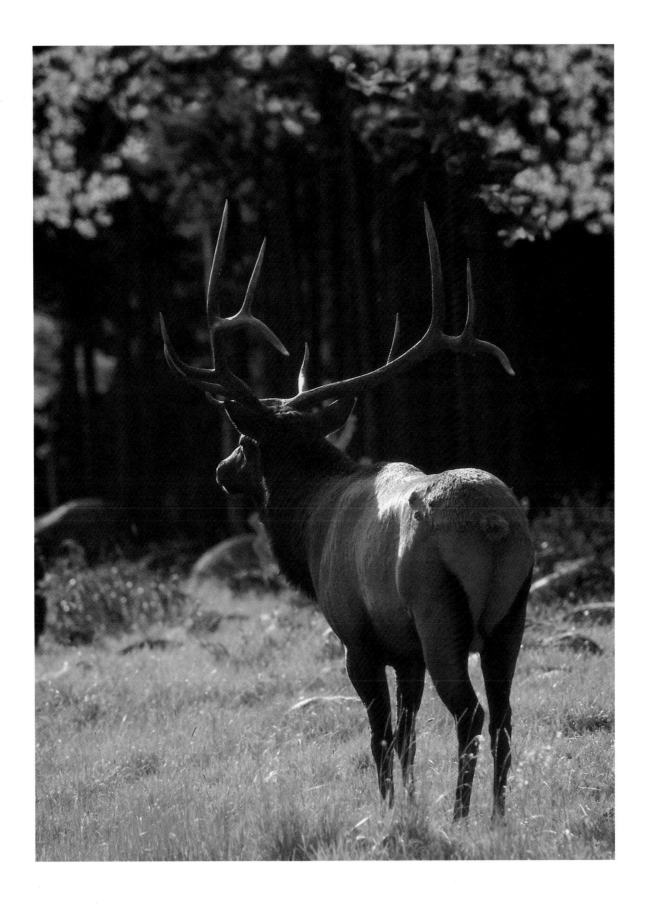

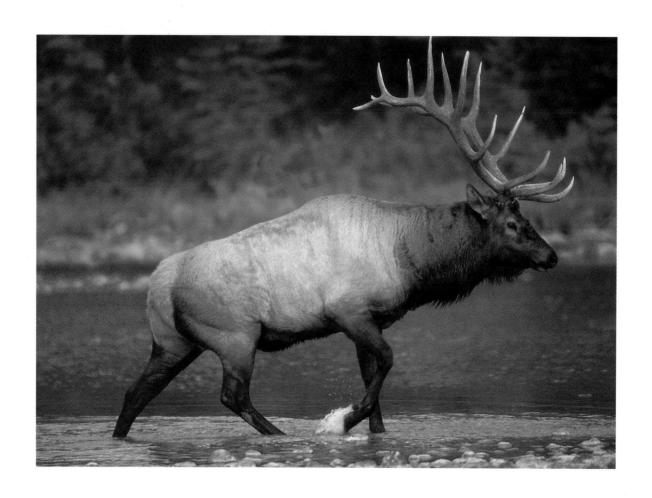

"*The huge shapely body… was set on legs that were
as strong as steel rods, and yet slender, clean and smooth.
They were a beautiful dark, brown color, contrasting well with
the yellowish of the body. The neck and throat were garnished
with a mane of long hair and symmetry of the great horns
that set off the fine, delicate lines of the noble head.*"

THEODORE ROOSEVELT

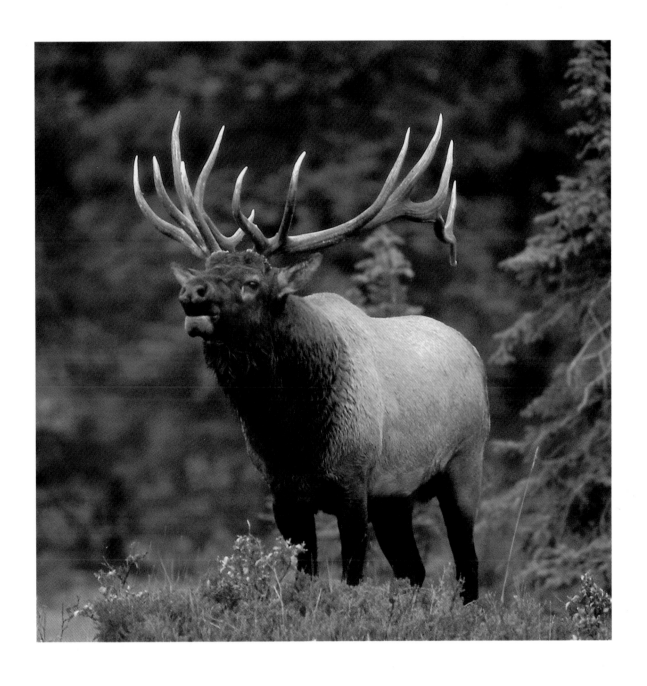

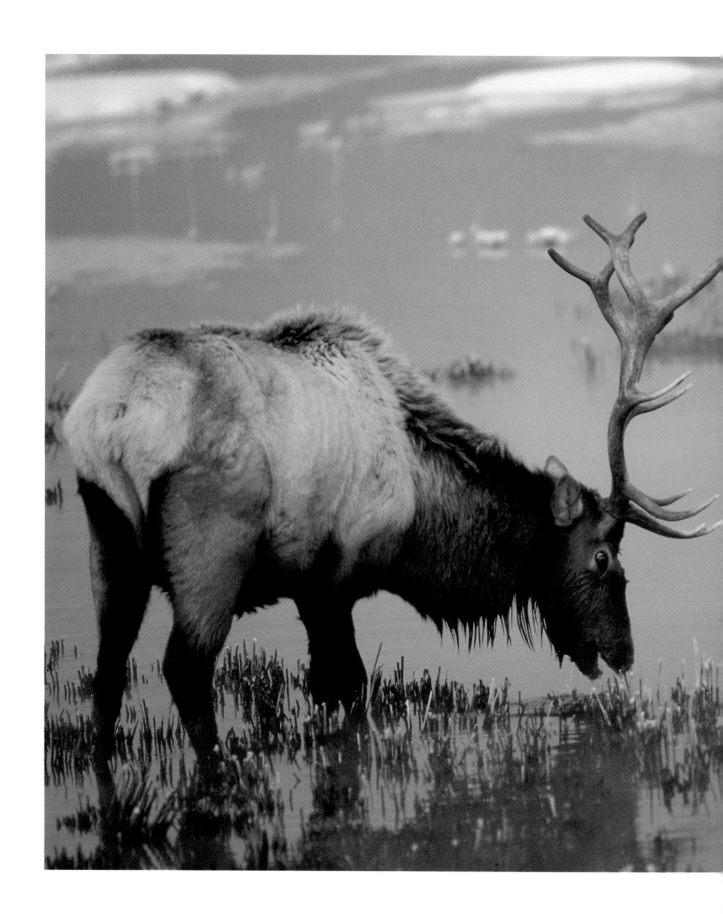

"*Nature is always lovely, invincible, glad, whatever is done and suffered by her creatures. All scars she heals, whether in rocks or water or sky or hearts.*"

JOHN MUIR

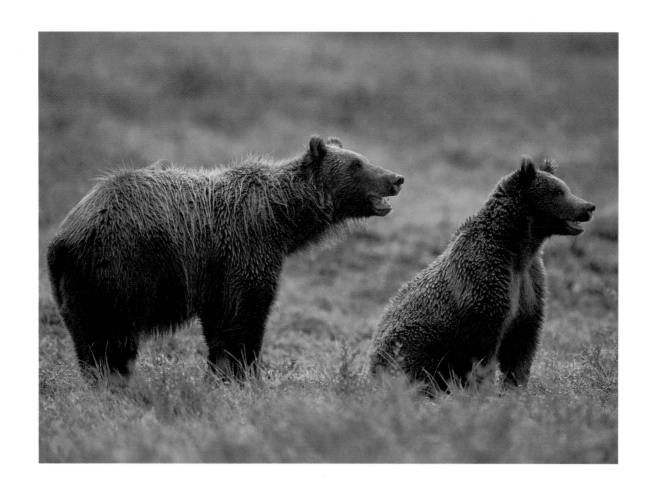

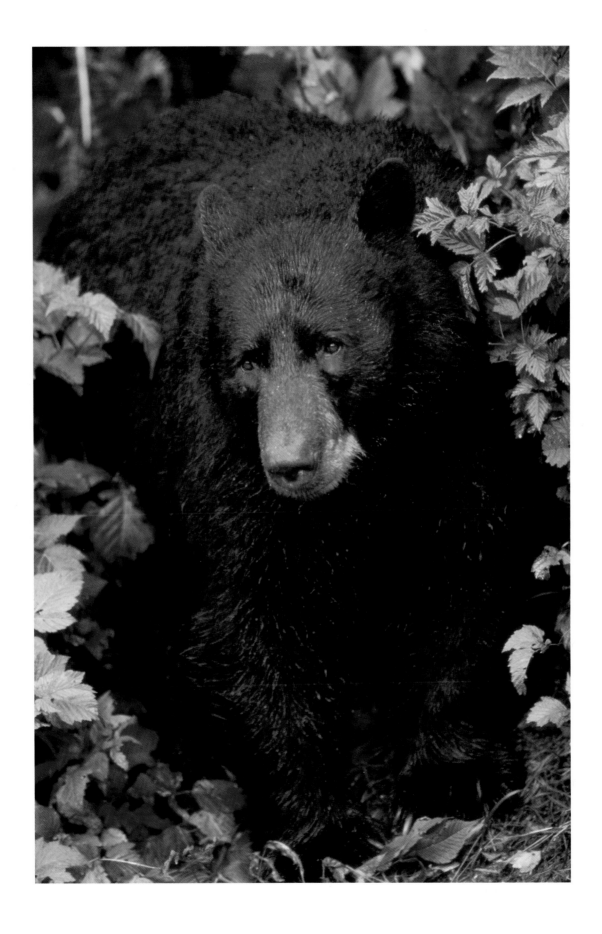

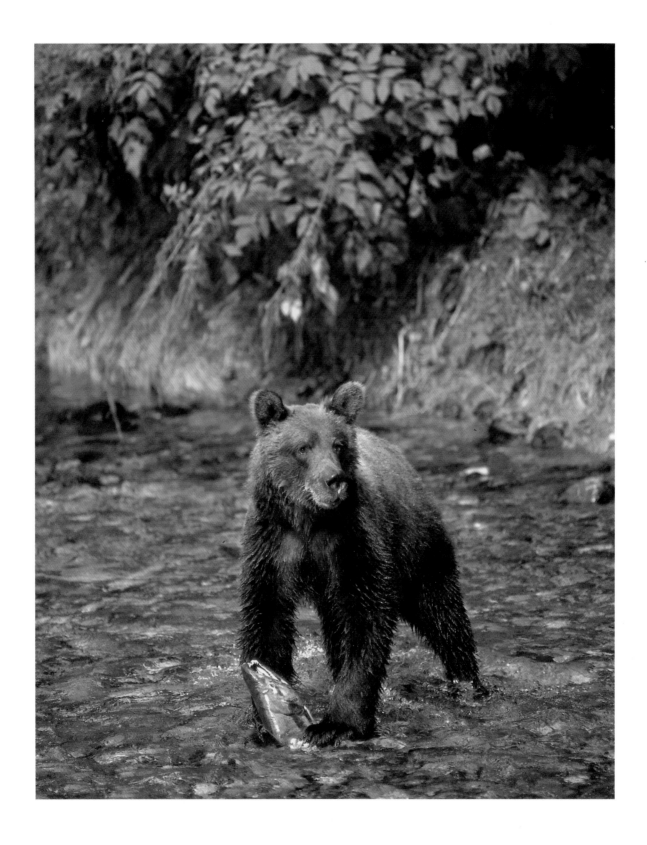

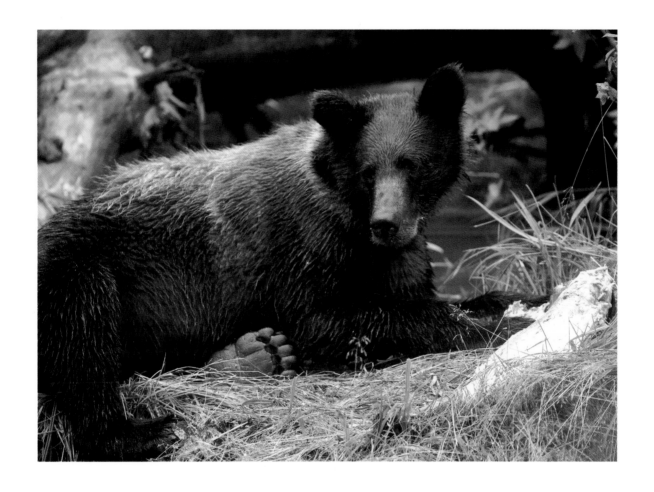

"*Deviation from nature is deviation from happiness.*"

Samuel Johnson

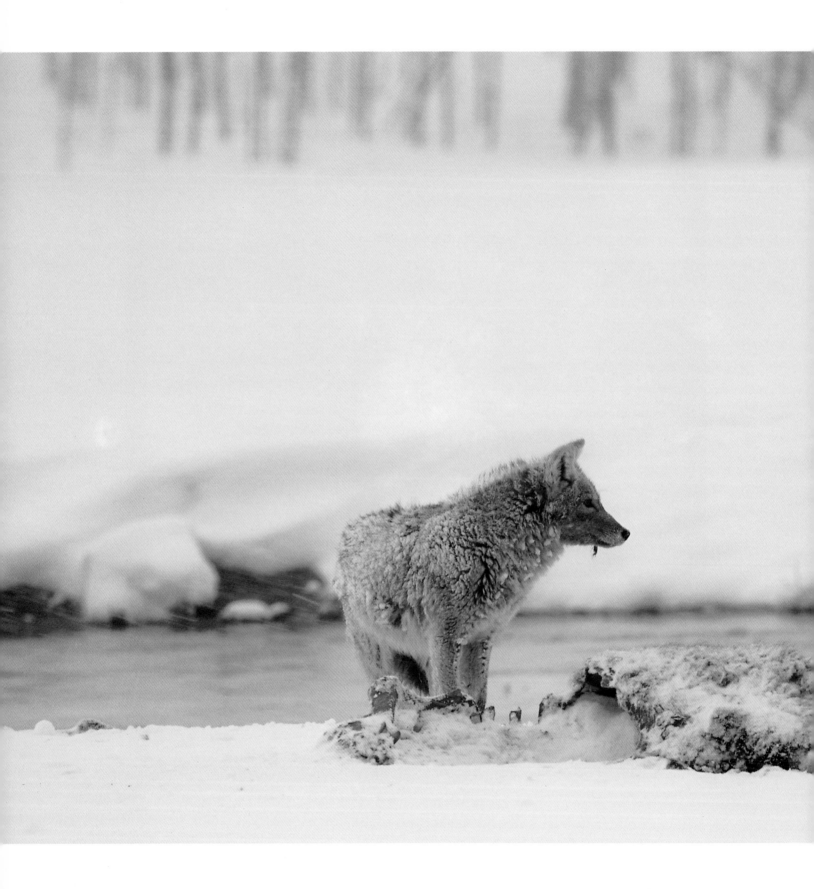

"*Nature subjects
the weak to the strong.*"

Seneca

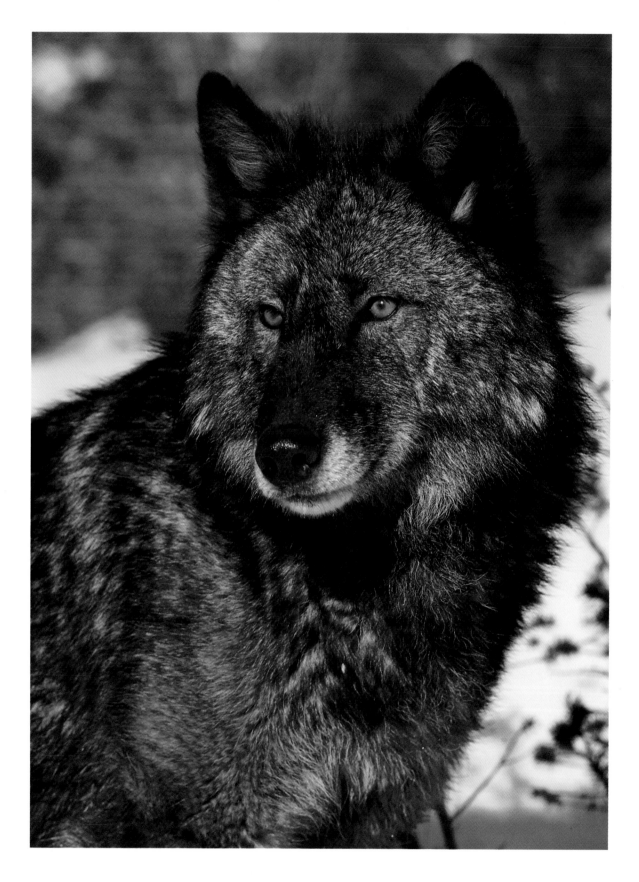

"*An animal's eyes have the power to speak a great language.*"

Martin Buber

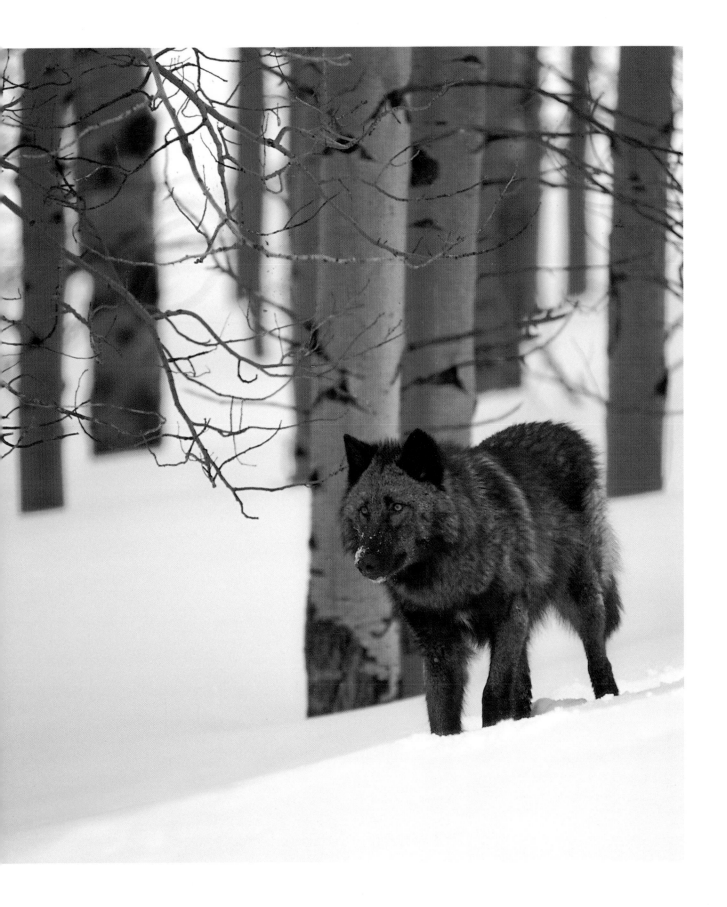

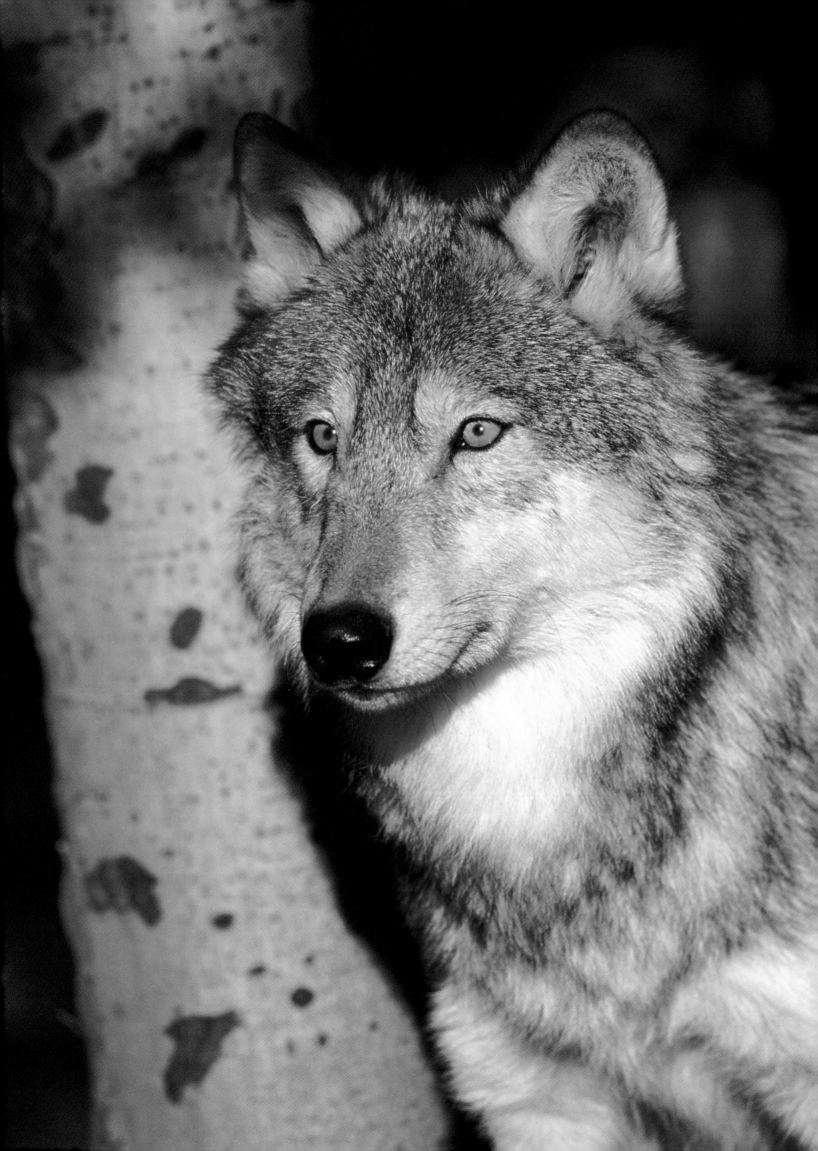

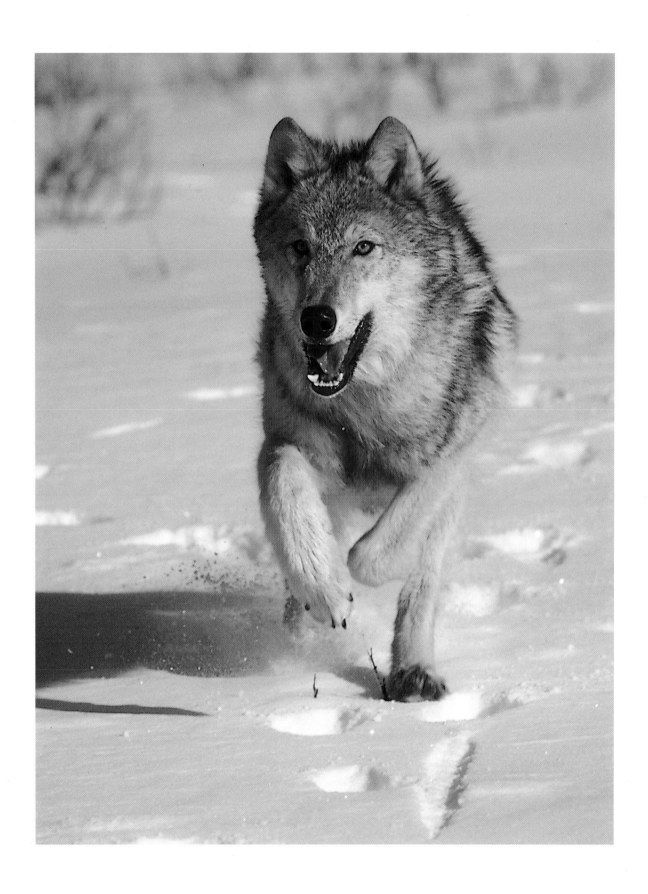

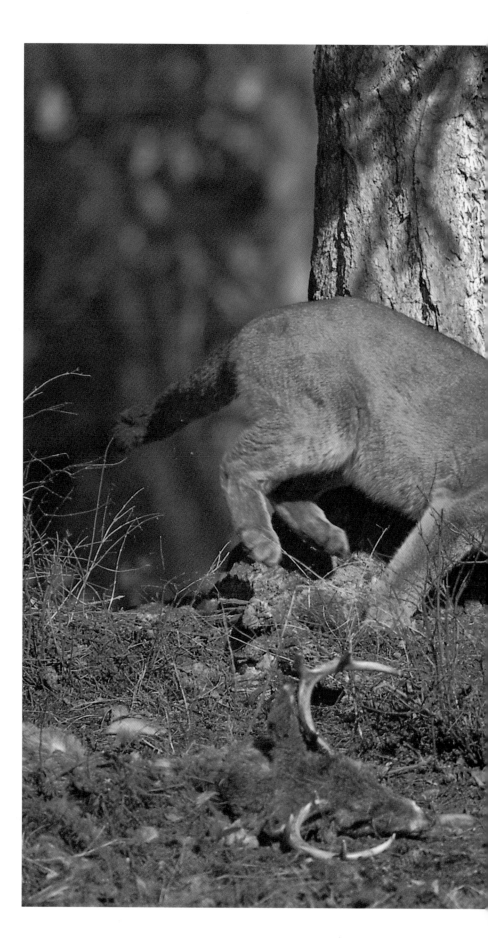

"All animals are equal, but some animals are more equal than others."

<small>GEORGE ORWELL</small>

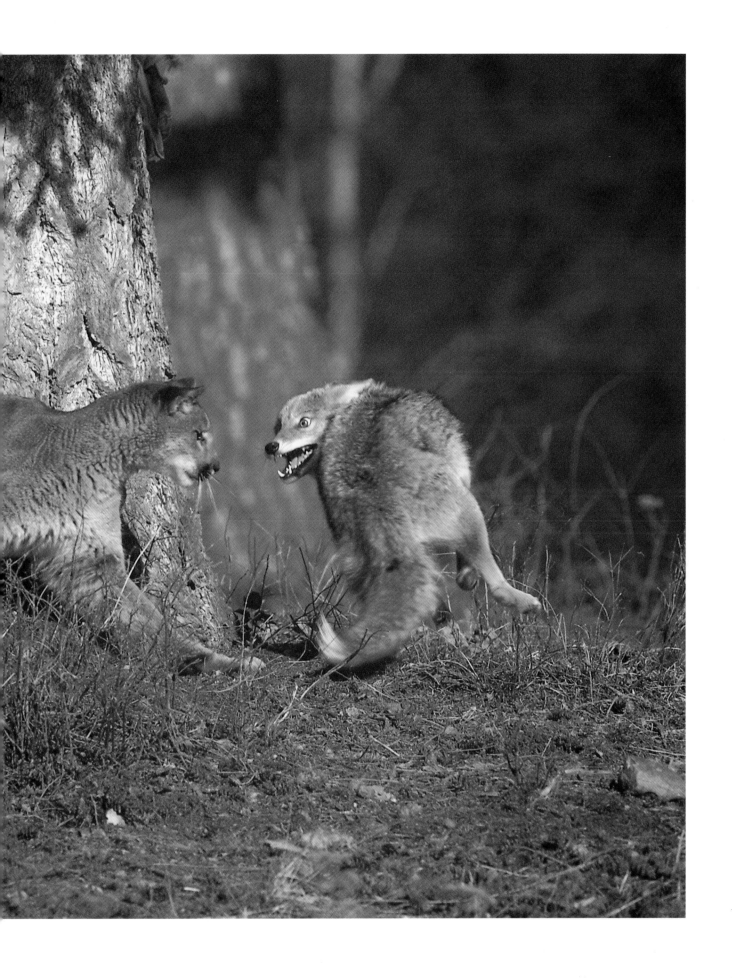

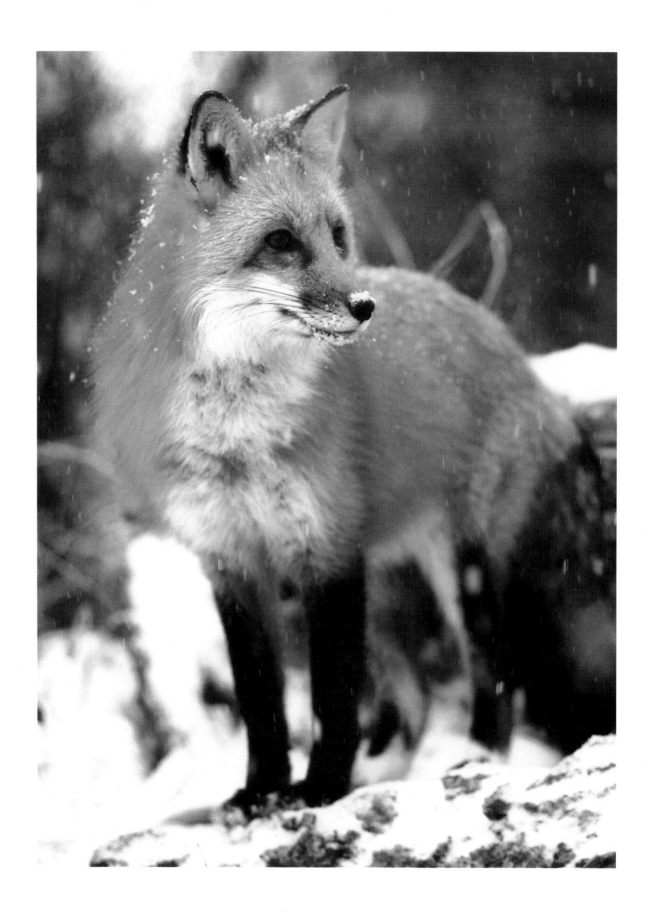

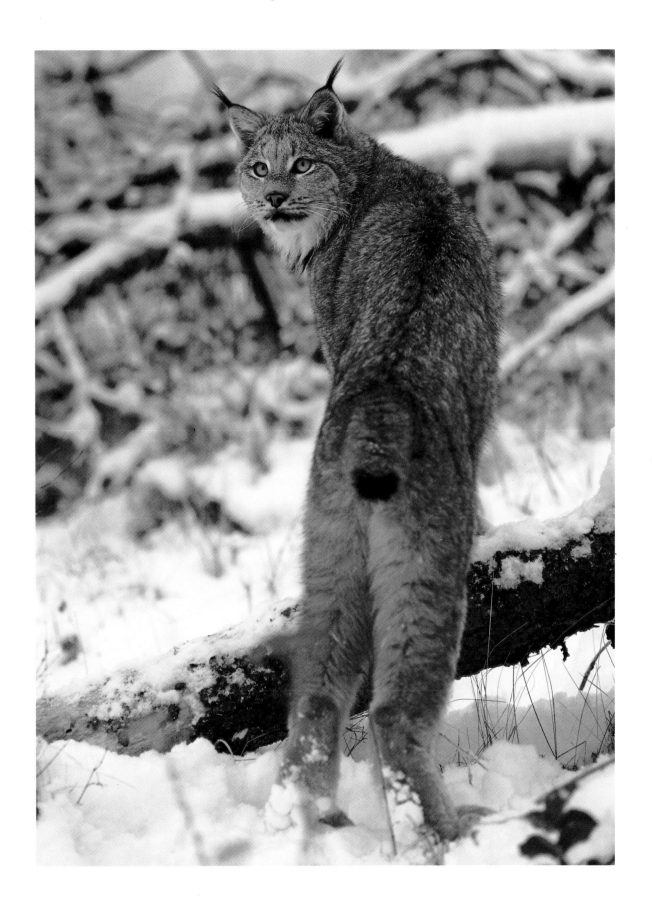

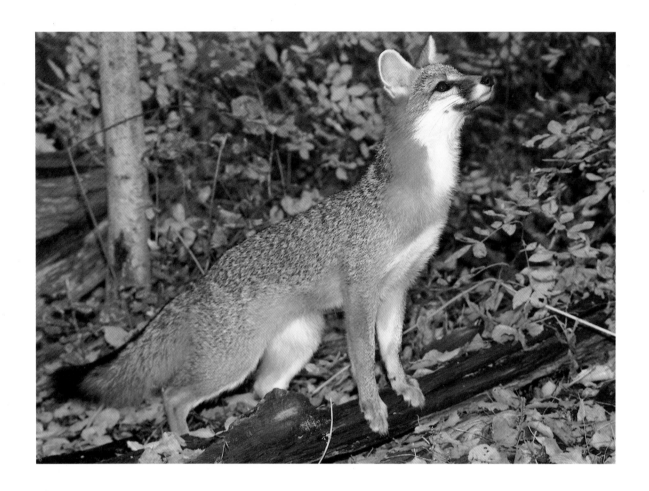

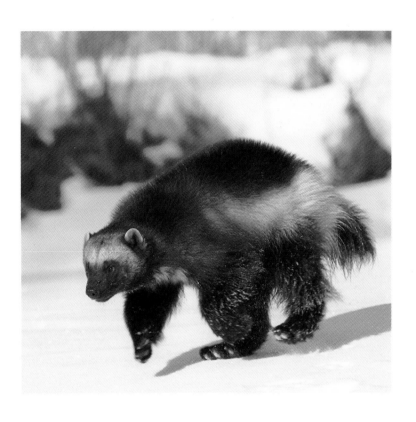

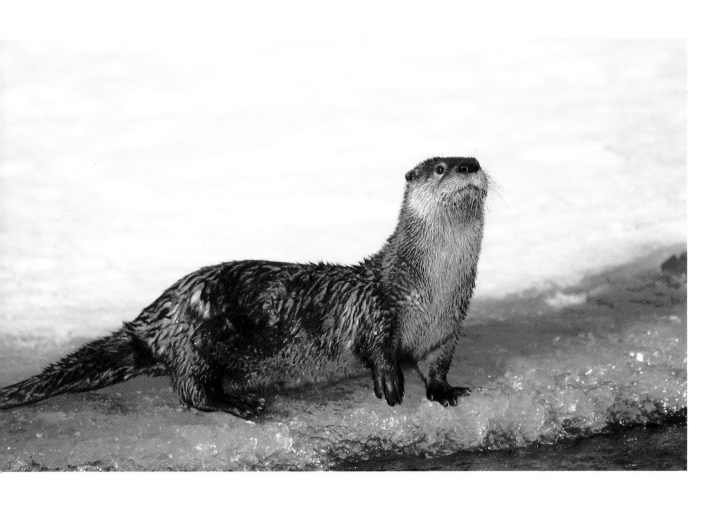

120

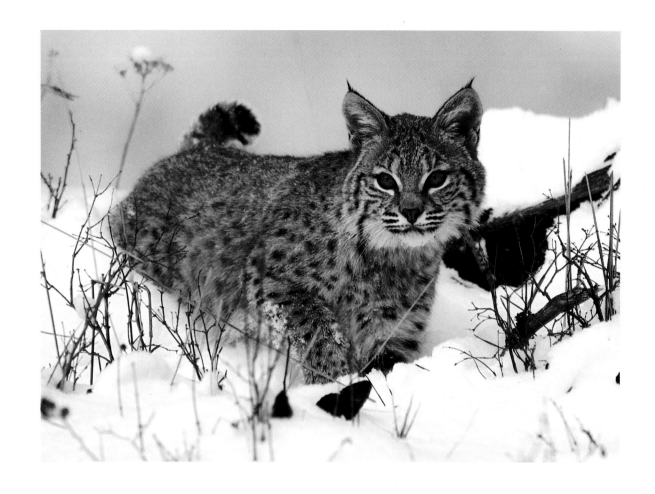

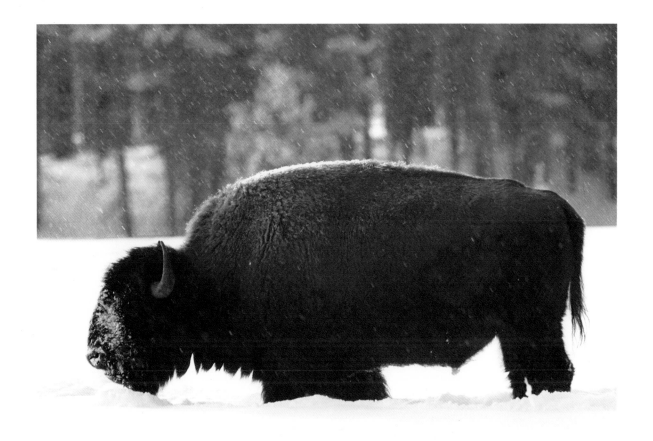

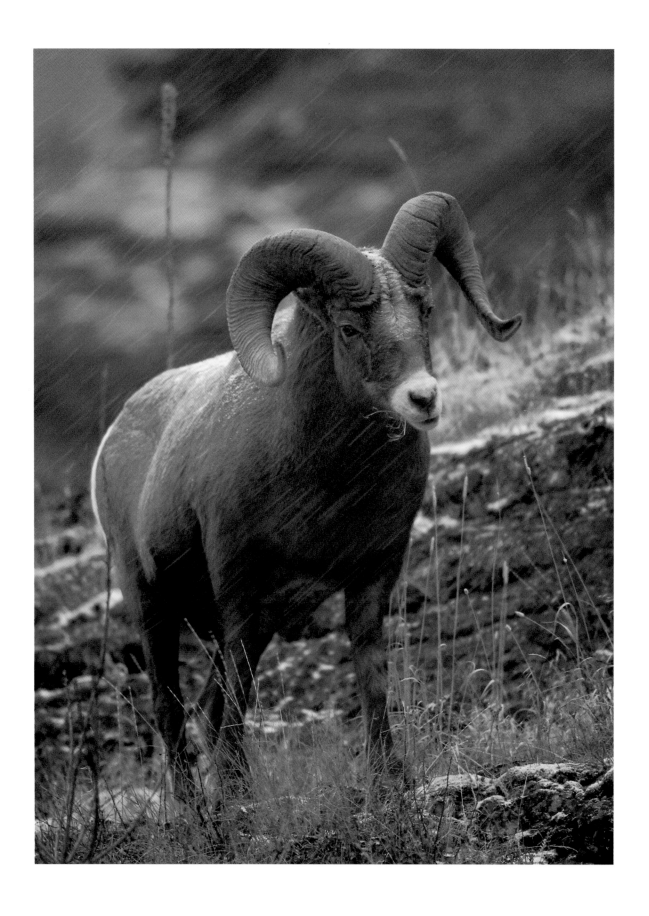

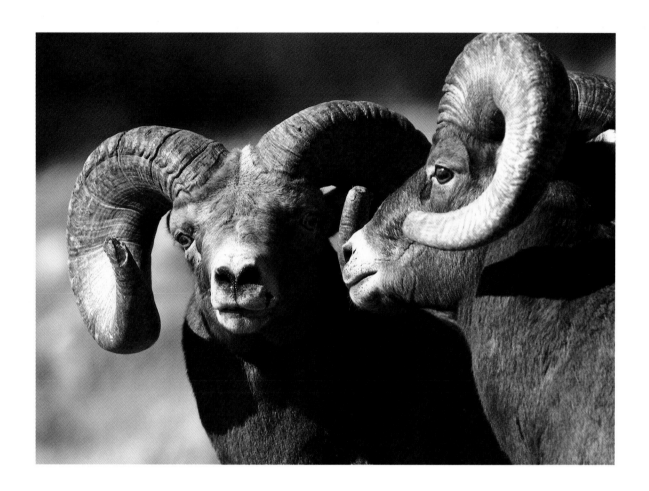

124

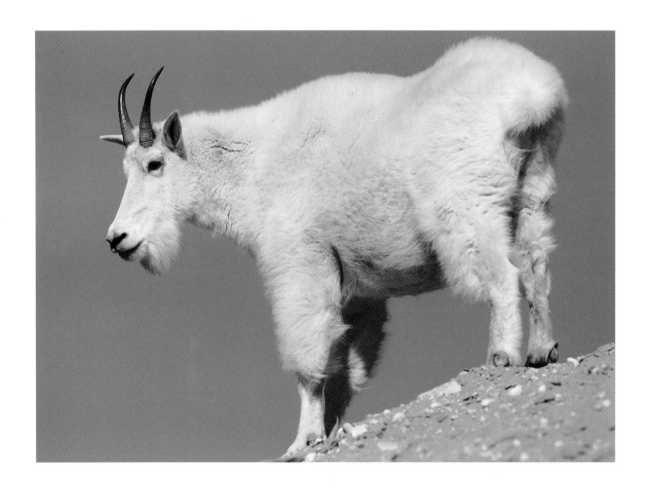

124

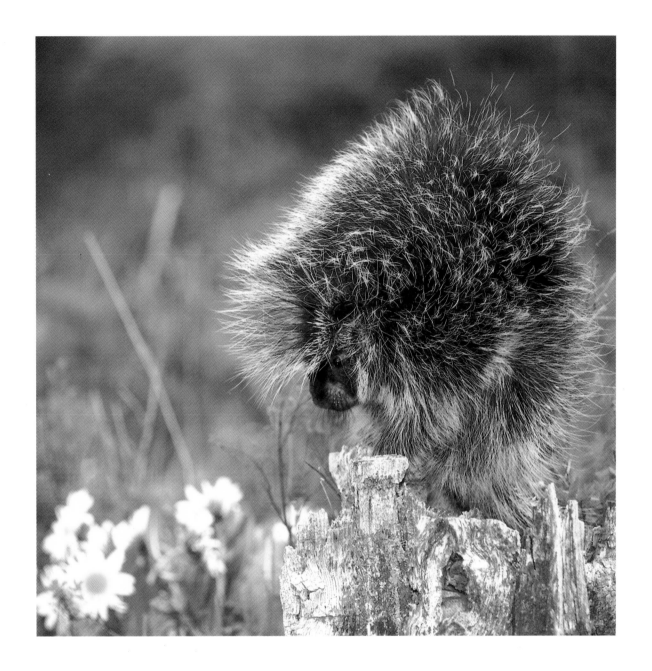

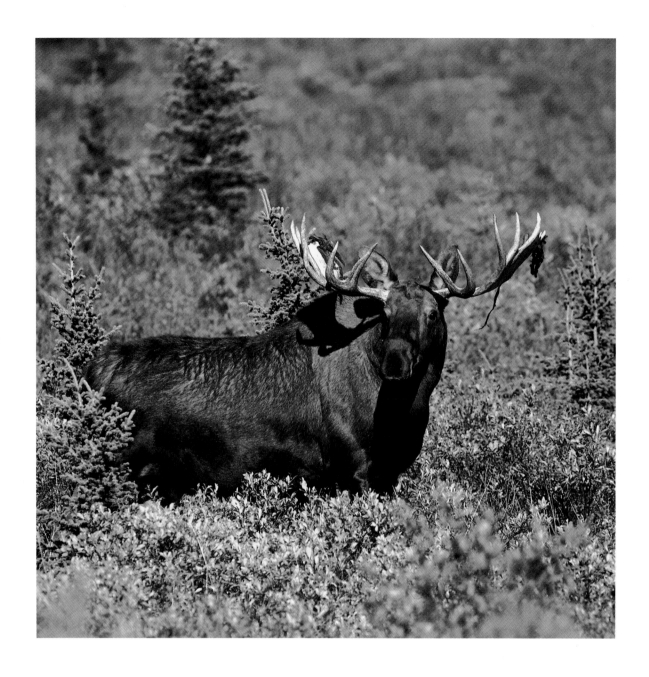

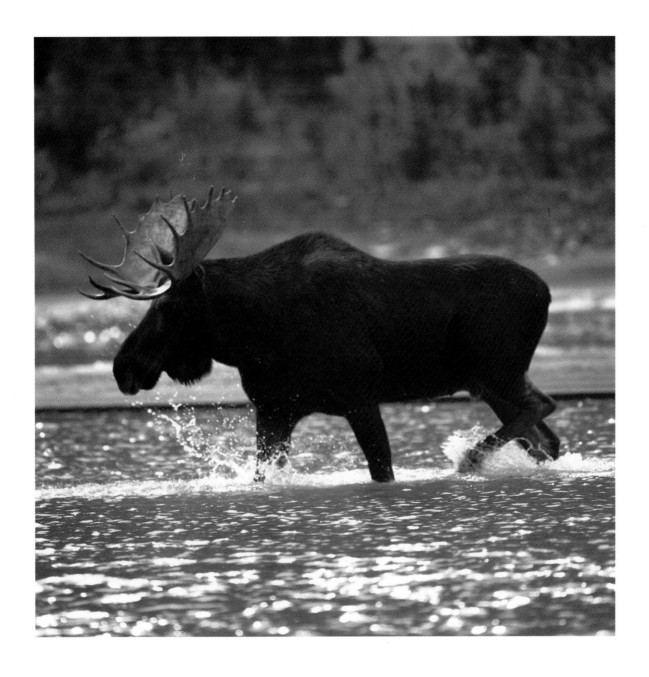

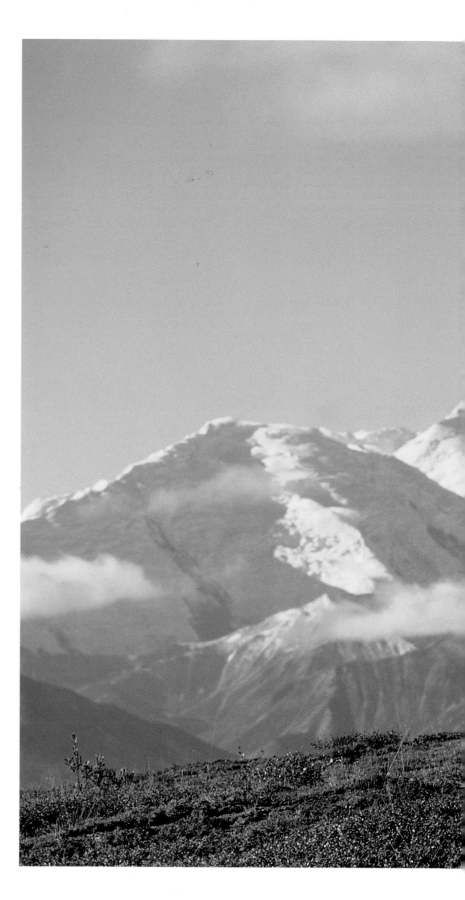

"*I will soon be off again… the mountains are calling and I must go…*"

JOHN MUIR

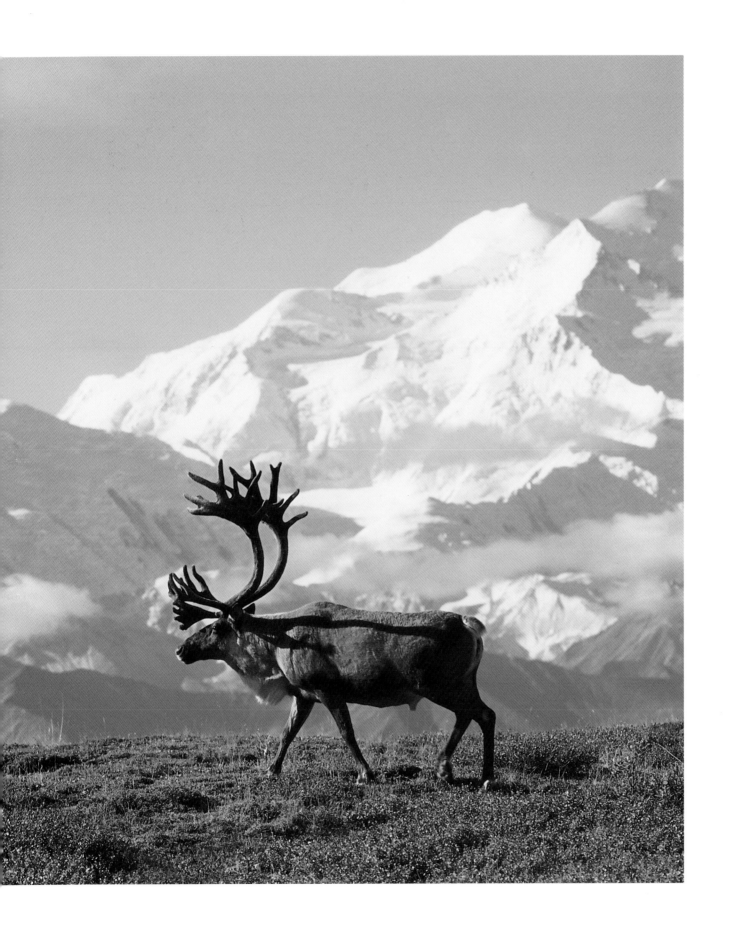

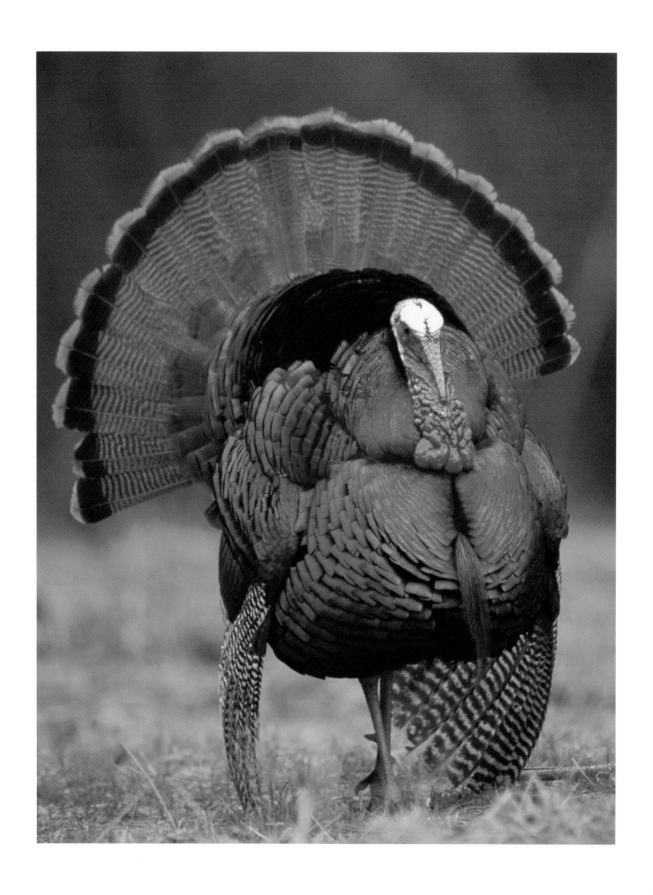

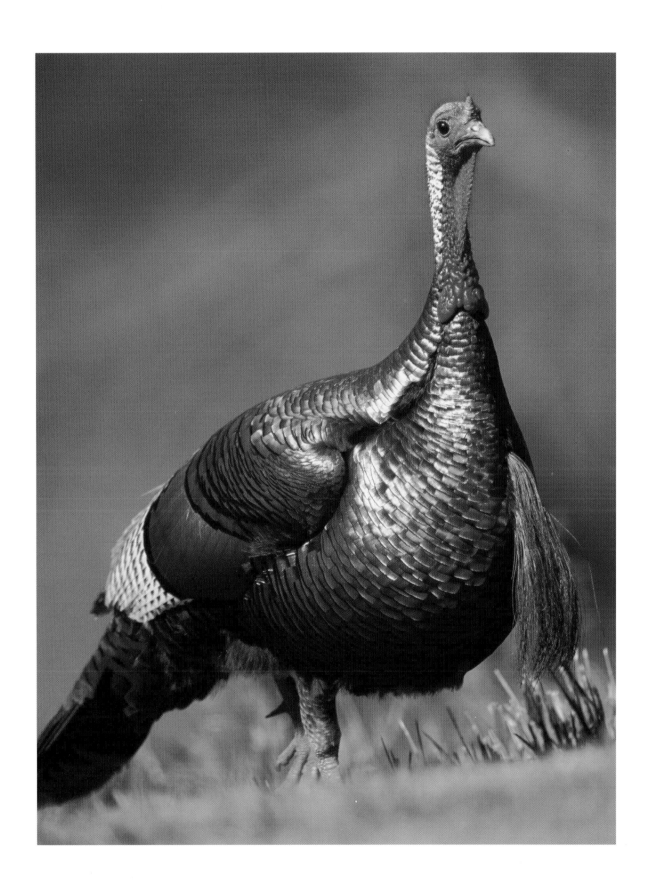

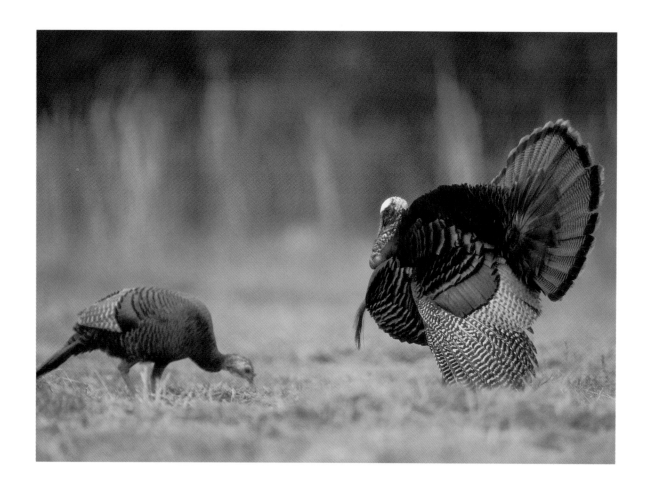

133

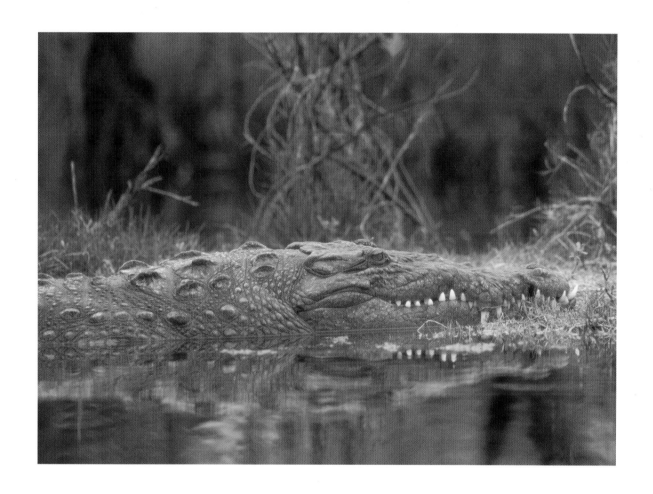

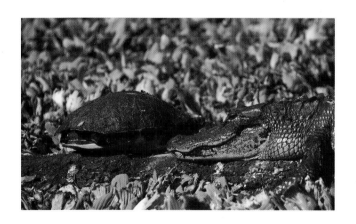

◀ *American Alligator and*
Florida Red-Bellied Turtle

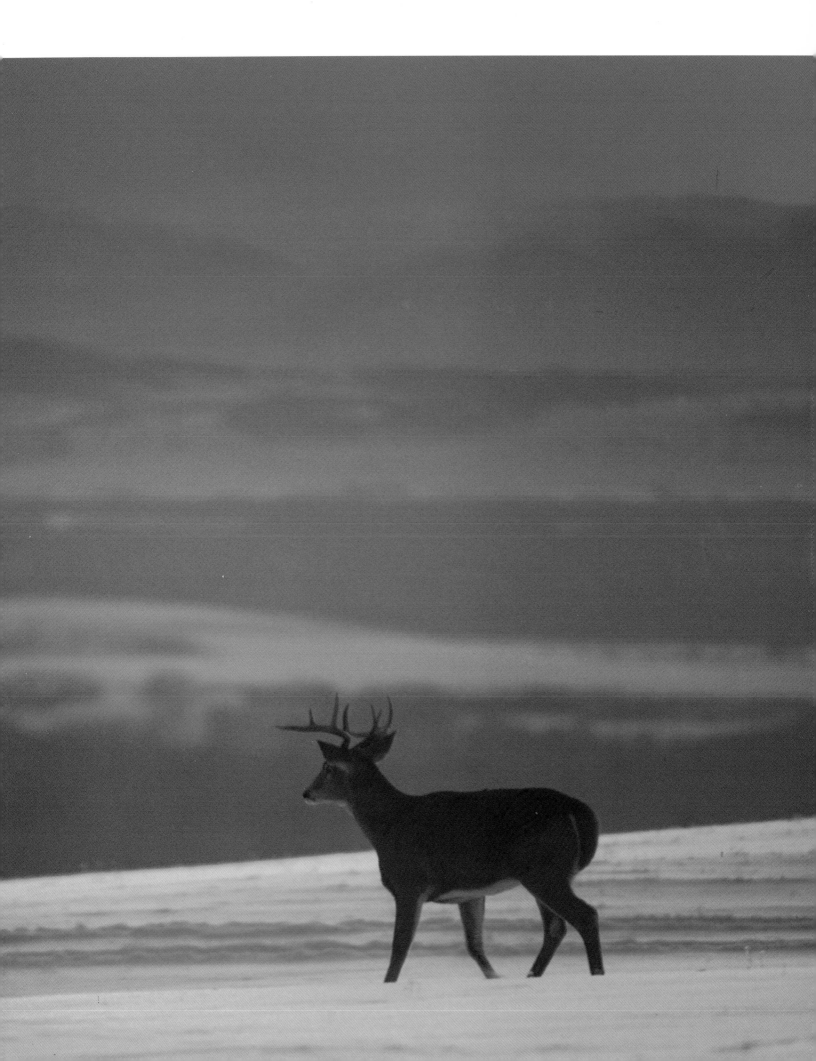

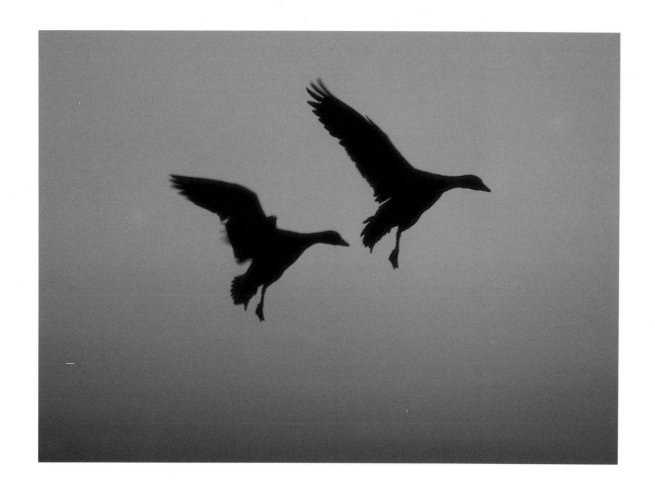

"*The day is done, and the darkness,*
Falls from the wings of night..."

HENRY WADSWORTH LONGFELLOW